L.S.LOWRYRA

Lowry at home, Mottram-in-Longdendale

L.S. LOWRY RA
1887-1976

4 September to 14 November

ROYAL ACADEMY OF ARTS
1976

Designed by Gordon House.
Printed in England by The Hillingdon Press, Uxbridge.

Preface

In November 1975 my predecessor, Sir Thomas Monnington, went to see L. S. Lowry at his home in Mottram-in-Longdendale to tell him of the Royal Academy's plans for mounting a major exhibition of his work at the Royal Academy in the Autumn of 1976. How deeply sad that neither has lived to see the opening of the exhibition but how splendid that their memorial should be so triumphant a celebration of Lowry's astonishing seventy years of artistic achievement and Sir Thomas's life-long belief in the continuity of the Academy as an institution at the service of art and artists.

Today, it is true, the industrial landscapes of Lowry's paintings are easier to remember than to find, but anyone who has visited the places he painted can still sense the underlying truthfulness of the vision he evolved to describe them and can respond to the understanding with which he laid bare the paradox of city life where so much bustling group activity can conceal so much individual loneliness.

As we all know such sharp-eyed truth and compassion brought enormous public recognition and affection. This response was won without short-cuts or easy tricks. Like all great art Lowry's art was drawn directly from the things he knew and had experienced. "Art" as he put it "was damned hard work".

So too was the task we set Professor Carel Weight, a lifelong admirer and friend of the artist, who was invited to undertake the immense task of selecting the works for this exhibition. The enthusiasm and energy with which he has gone about this task is only equalled by the perceptiveness of his choice. He deserves the Academy's deepest thanks. All his efforts, however, would have been meaningless without the extraordinary generosity of the many public and private collectors, headed by Her Majesty The Queen, who have lent to the exhibition. It would be invidious to thank some lenders without naming them all, the more so since some of them have preferred to remain anonymous. I must, however, make one exception and draw attention to the outstanding helpfulness of the Cultural Services Committee of the City of Salford which is the fortunate owner of the largest collection of Lowry's work and of Mr. Stanley Shaw, the Curator of Salford Museum and Art Gallery, who dealt so patiently and efficiently with our many requests for help and information.

We are grateful also to Mervyn Levy, writer and critic, for his spirited introduction to the catalogue and for the helpful and lively entries he has contributed to its pages. I cannot end without the warmest thanks to all those friends and admirers of the artist who contributed to the "Tribute to Lowry" section in the catalogue. What a marvellously varied and moving picture they paint of one of the Royal Academy's best loved Members, and one of the great English painters of this century.

Hugh Casson
President of the Royal Academy

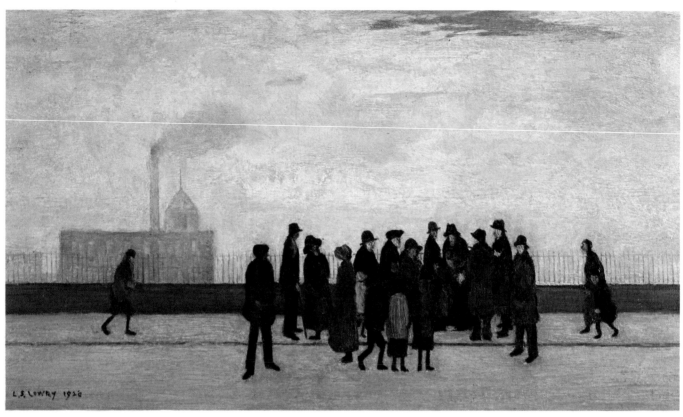

30 Sudden Illness 1920

Introduction

It is not too early to begin an assessment of L. S. Lowry's stature, or to hazard an informed view of his ultimate place in the patterns of European art. This is the right moment, and the right occasion. Although the artist died as recently as February of this year he left an exceptionally complete and extensive *oeuvre*, wide in range and well enough known to make such an evaluation possible. The length of his working life (some seventy years are spanned by this exhibition), the depth with which one can survey the long process of his creative evolution through a clean-cut succession of phases and periods, varied subjects and technical methods, each resolved with a dedicated thoroughness, present a rounded picture of a master untroubled at any stage of his work by the problems which bedevil the art of lesser men. There was no conflict of vision and style; no problem of matching the dream and the manner of its technical expression. The twin streams of concept and of technique ran easily, hand in hand, and were instantly married at the point of flow from brush, or pencil. Hard work there was certainly – Lowry was no slippery virtuoso – and he was the first to insist that painting was "damned hard work." Beyond the passion – and there is passion in these drawings and paintings – exists a reflective calmness, a serenity and a grandeur which will certainly secure for the artist a niche in the Western pantheon.

L. S. Lowry's greatness is rooted in the classical rather than the emotive stream of European art. In this sense, and at his finest, he is closer to the "architectural" masters of the middle trecento than the rhetorical gesturing of the high Renaissance. Closer to the Lorenzetti or Maso di Banco than to Michelangelo or Tintoretto. The comparison is of course one of technical concept, not vision. Lowry's early drawings from the life and the immaculate line drawings of the 1920's are witness to the fact, and to the quality of passion – the sheer strength of his enthusiasm – as distinct from cloying emotionalism, which is the foundation of his art.

What, however, are the elements which combine and fuse in the rare few – and they are few – to produce "greatness"? In order to understand the nature of Lowry's stature we must first set out these qualities. The clue, as so often happens, came to me during the course of a conversation. Talking recently with the dealer Anthony d'Offay, always an astutely perceptive critic, I asked how he now saw the work of the artist? After a brief reflection he answered: "I have seen large industrial paintings of the Forties and Fifties that I thought were masterpieces." This observation, though an apparently simple aside, is complex in its implications, and contains, I think, the key to what it is I want to say about the nature of greatness. A small talent has no option but to find, and as quickly as possible, a commonplace level of subject appeal linked to a shallow and superficially distinctive style which rapidly degenerates into cliché. The artist of genius, however, evolves in three distinct phases. There is an early and formative period during which he strives to emerge from the chrysalis of those attendant sources of influence, the teachers and heroes who shape his origins. This is the point at which he struggles to find his own identity, and his own mark. There is a

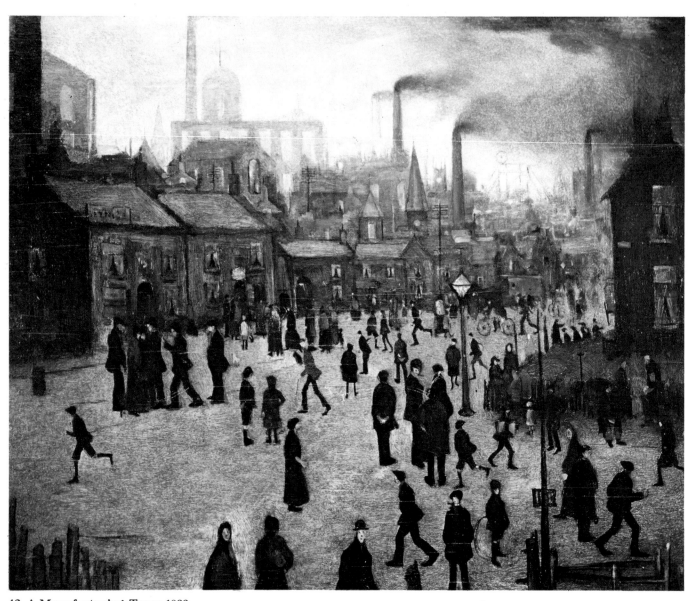

43 A Manufacturing Town 1922

consolidating, "high" middle period in which his key masterpieces are created, and a late phase in which his powers assume a more relaxed form. In his formative years Picasso was obliged to shed a conglomeration of clamouring influences. Lowry, a far less complicated master, had to resist and free his vision only from the directing eye of his teacher at the Manchester College of Art, Adolphe Valette. A brilliant, though limited painter in his own right, Valette practised in those early years a brand of Impressionism which Lowry was to adapt to his own ends at many points throughout his life. But the vision, and his dream, were unique. The early years were steeped in a lengthy apprenticeship to the craft of academic drawing – he was an art student for upwards of twenty years – a keen interest in landscape, and the gradual awakening of his passion for the industrial scene to which subject he was totally committed by the 1920's. This would remain the dominating "fever" of his existence. The great industrial "visions" (for so he described them) of the middle years are unquestionably his masterpieces. They ceased in this period to be mere slavish and topographically accurate accounts. His finest paintings, by his own admission, were "composite" often combining in the one, magnificent scheme, factual as well as invented elements drawn from a variety of sources. So, the Stockport Viaduct, an image which always haunted the imagination of the artist often appears in made-up pictures. As do the yachts at Lytham-St Annes. These he often saw on childhood holidays with his parents. They re-appear over the years in dreamlike evocations of those long ago holidays; a touching tribute to his mother's love of their old holiday resort.

The townscapes of these middle years, teeming with figures, mills, factories, buildings and smoking stacks are an expression of Lowry's vision of the industrial north distilled with poetry, elegance, and a breath-taking clarity of design. They are not only aesthetic masterpieces, but in the scurrying anonymity of his people, parables of man's destiny as the least consequent of God's ants. The artist always viewed his fellows with a satirical rather than a sentimental eye. He was primarily an observer, frequently using humour and ridicule to intensify his view of man's insignificance. By the mid-fifties, Lowry was entering his long period of "winding down". The crowds give way to small groups of people or solitary personages often set in empty, or near empty areas of white. They are painted more freely, with a relaxed and casual, though always cunning brush. The tension of the earlier years is now reserved for drawings in pencil and felt-tip pens. Many of these late drawings are rendered with a shattering punch. Frequently savage, they mock at groups of hooligans on the way to a football match; a tramp munching a sandwich disgorged from a dust-bin; children fighting.

If Lowry painted little in his later years he certainly continued to draw with un-dimmed passion, and a mischievous, rugged strength that reminds one of Picasso's late work. Both men were still brilliantly alert in their eighties.

The sheer volume of Lowry's output was also huge, and what makes his achievement even more astonishing are some biographical facts I am now able to reveal in detail. It is commonly believed that the artist never needed to earn his living; that he was supported by his parents, first by his father who died in 1932, and then by his mother until her death in 1939. Lowry was then fifty-two. The truth is very different.

From his sixteenth year until his sixty-fifth birthday, with the exception of a few weeks unemployment in 1910, L. S. Lowry was fully employed. He worked the usual humdrum nine to five week like countless other people. On 21st March 1910 he wrote to The Pall Mall Property Company Ltd., in Manchester applying for a job he had seen advertised in the *Manchester Guardian*. The letter is included in the exhibition (illus. p. 53). Previously he had been employed by the General Accident and Life Insurance Corporation Ltd. of Manchester as a Claims Clerk. In January of that year he had been made redundant.

But even before this job came to an end after some two and a half years he had already been employed for four years by Thos. Aldred and Son, Chartered Accountants, of 88 Mosley Street, Manchester. He was taken on the strength of the Pall Mall Property Company Ltd. in 1910 and remained in their employ until his retirement in 1952. Starting as a full-time rent collector and clerk, he was later promoted to Bookkeeper, and finally to the rank of Chief Cashier, a position he held until his retirement on full pension at the age of sixty-five. A few years later he presented the Company with a painting which now hangs in their Board Room. (257)

In terms of his evolution as a painter this accounts for the great length of time he spent as an art student. Not as a full-time, but as a part-time student attending evening classes. From 1905 to 1915 he studied at the Municipal College of Art, Manchester and from 1915 to 1925, on and off, he attended classes at the Salford School of Art. He had to work extremely hard at these evening classes to acquire the training and knowledge he so diligently, patiently, and painstakingly gathered.

The fact almost certainly explains the technical hesitancy of his early art school drawings. Unlike other more naturally gifted painters of his generation he was no rip-roaring art student with a pint in one hand and a piece of red chalk in the other. He possessed none of the glittering, but shallow virtuosity that so often accompanied the bohemian life-style of the day. What Lowry achieved was by dint of hard work. In his own words: "Painting is damned hard work". It also means, as he told me, that most of his finest pictures were produced at night – often through the long, still hours of the night – after a full day's work, and by gas or electric light. If one bears in mind that a painter of Lowry's calibre invariably needs to work at his own pace, in suitably chosen hours, and in carefully selected conditions of lighting, one can only marvel at the prodigious strength of dedication which made it possible for the artist to produce in a relative fraction of the time at the disposal of any other comparable master, a life's work of such size and quality.

It also accounts for certain idiosyncrasies of vision and style which may until now have mystified the observant spectator. Why, for instance, are there *no shadows* in his pictures? He once told me this was because shadows would "mess up the composition." At the time this seemed a perfectly acceptable reason. I now think it has more to do with the fact that in working so much by artificial light he was not in a position to observe and study shadows out of doors, and so conveniently omitted them. Most probably without even considering the matter. It may also account for the arbitrary character of his colour, and explains his enduring passion for the pencil. A medium easy to use by artificial light.

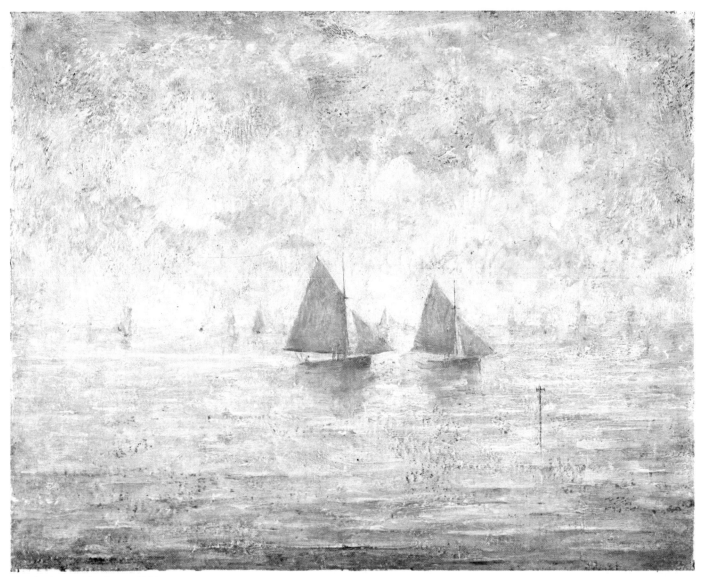

49 Yachts at Lytham 1924

Other men in regular employment have pursued their creative skills as a pendant to a routine job. None, to my knowledge, except L. S. Lowry has done so, and at the same time made a major contribution to the history, and substance of an art form. His achievement is a miraculous testament to the always mysterious nature of genius.

Mervyn Levy
London 1976

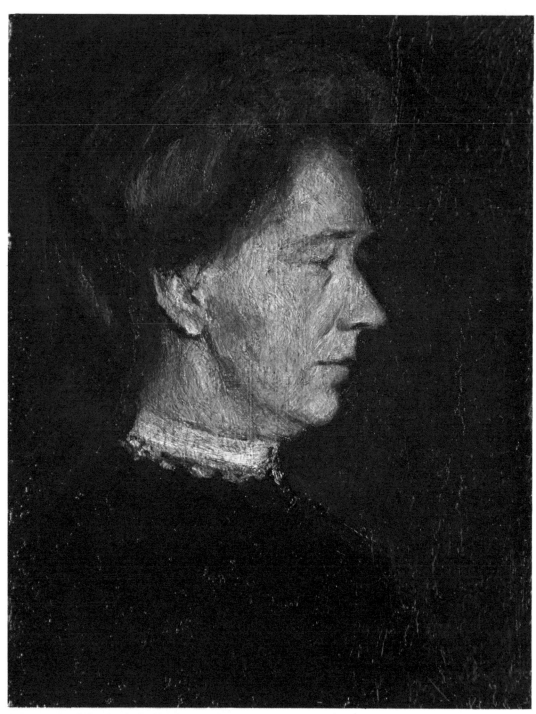

8 **Portrait of the Artist's Mother** 1910

Biographical chronology of the artist

1887
Laurence Stephen Lowry born in Manchester, 1 November. Only child of R. S. Lowry an estate agent, and Elizabeth Hobson. The family lived in Rusholme, a suburb of Manchester.

1895–1904
Educated at Victoria Park School, Manchester. On leaving he attended the private painting classes of William Fitz in Moss Side, Manchester.

1904
Joined the firm of Thos. Aldred & Son, Chartered Accountants, 88 Mosley Street, Manchester, where he worked as a Clerk.

1905–15
Studied drawing and painting at the Municipal College of Art, Manchester.

1907
Joined the General Accident, Fire & Life Assurance Corporation, 20 Cross Street, Manchester, as a Claims Clerk.

1909
Moved with his parents from Rusholme to 5 Westfield, Station Road, Pendlebury, in Salford.

1910
Began work as a Rent Collector and Clerk with The Pall Mall Property Company Ltd., Manchester.

1915–20
Began to develop his interest in the industrial scene. During this period he also attended drawing and painting classes at the Salford School of Art, and continued to do so, infrequently, until 1925. His art school associations thus continued over a period of some twenty years.

1926–30
During this period he exhibited in open exhibitions in Manchester and at the Paris Salon. *An Accident* was bought by the City Art Gallery, Manchester. This was the first of his paintings to be acquired by a public art gallery. Commissioned to illustrate *A Cotswold Book* by Harold Timperley (Jonathan Cape, London 1931).

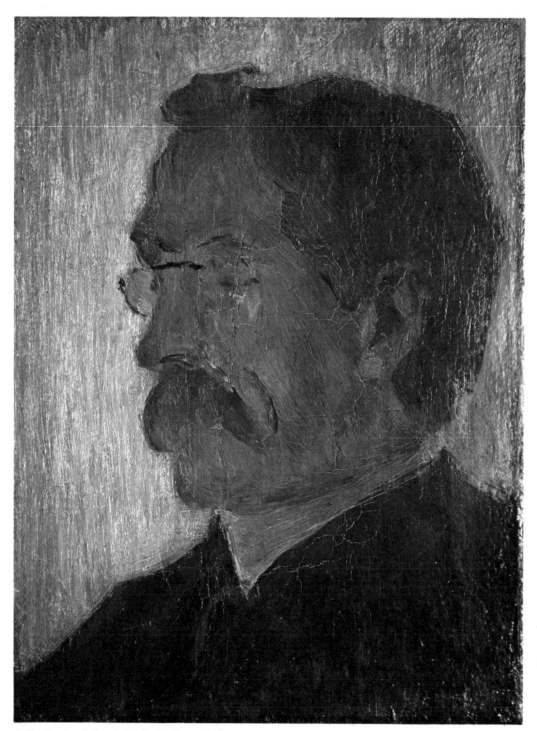

9 **Portrait of the Artist's Father** 1910

1932

His father died. First exhibited at the Manchester Academy of Fine Arts. First exhibited at the Royal Academy.

1934

Elected a member of the Royal Society of British Artists.

1936

Six of his paintings were shown in a mixed exhibition at the Arlington Gallery, London.

1938

Chance discovery by A. J. McNeil Reid who saw some of his paintings while visiting the framers, James Bourlet & Sons Ltd.

Photograph of L. S. Lowry as a Child, *c.* 1894
Private Collection

Photograph of L. S. Lowry as a Young Man, *c.* 1917
Private Collection

1939

First one-man exhibition at the Lefevre Gallery. He exhibited there on some thirteen occasions. *Dwellings, Ordsall Lane, Salford* purchased by the Tate Gallery. In October his mother died.

1941

An exhibition of the artist's work was presented at the City Museum and Art Gallery, Salford.

1943

One-man exhibition at the Bluecoat Chambers, Liverpool.

1945

Made Honorary M.A., University of Manchester.

1948

Elected a member of the London Group. Moves from Pendlebury, Salford, to The Elms, Stalybridge Road, Mottram-in-Longdendale, Cheshire, where he lived until he died. October: one-man exhibition at the Mid-day Studios, Manchester, where he exhibited regularly with the Manchester Group from 1946-1951.

1951

July-August: retrospective exhibition at the City Art Gallery, Salford.

1952

First exhibition at the Crane Gallery, Manchester. This gallery, under the direction of Mr. Andras Kalman, was the first commercial gallery outside London to show Lowry's work. Further exhibitions were held there in 1955 and 1958. Now the Crane Kalman Gallery, London, it has shown his work on a number of occasions. Lowry is represented in the Collection of the Museum of Modern Art, New York. Retired on Full Pension from The Pall Mall Property Company Limited, Manchester, with whom he began work as a Rent Collector and Clerk in 1910. At the time of his retirement he had risen to the rank of Chief Cashier to the firm.

1955

Made an Associate of the Royal Academy. An exhibition of his work held at the Wakefield City Art Gallery.

1959

June-July: retrospective exhibition at the City Art Gallery, Manchester. Exhibited, Robert Osborne Gallery, New York.

1960

April-May: exhibition of drawings and paintings at the Altrincham Art Gallery.

1961

Made Honorary LL.D., University of Manchester.

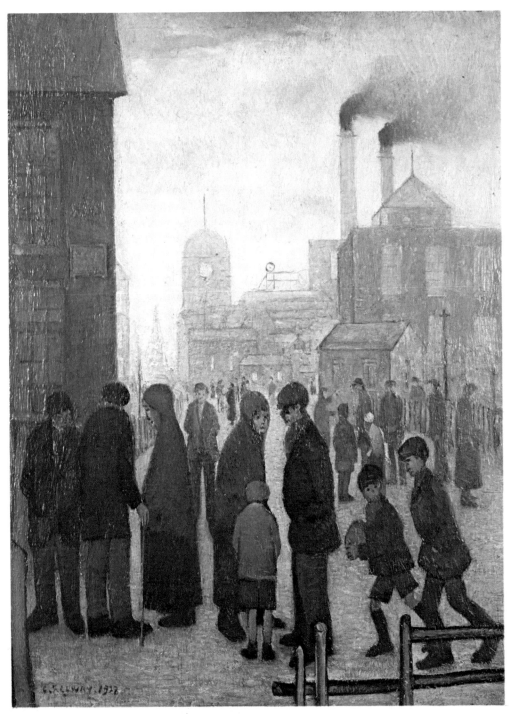

80 Salford Street Scene 1928

91 Outside the Mill 1930

1962

Elected Royal Academician. September-October: retrospective exhibition at the Graves Art Gallery, Sheffield.

1964

In November, an exhibition in his honour was held at the Monks Hall Museum, Eccles. Twenty-five contemporary artists, including Henry Moore, Barbara Hepworth, Ben Nicholson, Duncan Grant and John Piper, took part. The Hallé Orchestra gave a special concert in Manchester to celebrate the occasion of his seventy-seventh birthday.

1965

June: received the Freedom of the City of Salford.

1966-7

Travelling retrospective exhibition organised by the Arts Council of Great Britain visited the Sunderland Art Gallery; the Whitworth Art Gallery, Manchester; The City Art Gallery, Bristol; and the Tate Gallery, London. On 10 July 1967 the G.P.O. issued a Lowry stamp reproducing a mill scene.

1971

Exhibition organised by the Northern Ireland Arts Council in Belfast.

From 1971 the artist lived quietly at Mottram making occasional visits to the Seaburn Hotel at Sunderland where he liked to stay for two or three weeks at a time. During this period he painted infrequently and showed mainly at the Royal Academy Summer exhibition, although he was not represented in the 1975 Exhibition.

1975

Made Hon. D.Lit. by the University of Salford.
Made Hon. D.Lit. by the University of Liverpool.

1976

On 23rd February, 1976 the artist died at Woods Hospital, Glossop, in his 88th year.

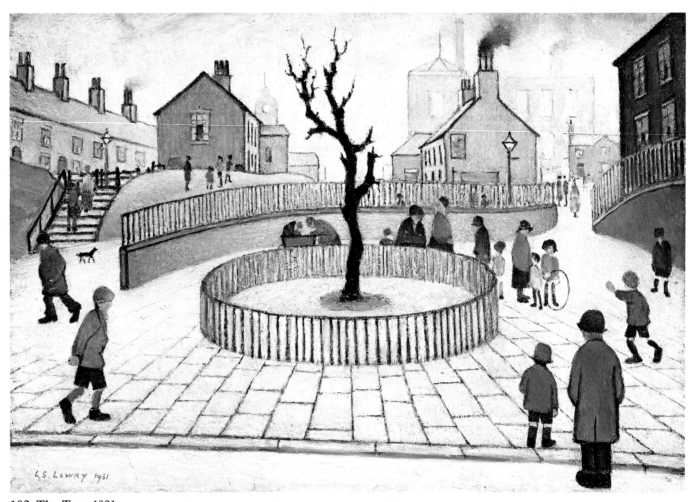

102 The Tree 1931

Tributes to L. S. Lowry

Like Wordsworth's "Leech Gatherer", Mr. Lowry's career is an example of resolution and independence. While every other painter of equal gifts has been worrying about new forms of expression, and has felt, however reluctantly, the influence of the dominant artists of the period, our leech gatherer has continued to scrutinize his small black figures in their milky pool of atmosphere, isolating and combining them with a loving sense of their human qualities. His early work already shows his feeling of local piety; but at some period in his career he made a discovery which was to give him a new basis of communication. It was a discovery as simple as Newton's apple or Columbus's egg; that the industrial landscape is not black, but white. Satanic mills may be dark when one approaches them, but in the humid valleys of the north they float in a perpetual, pearly mist, and only the foreground figures, in their doleful working clothes, are dark. This discovery was like the sudden, unprejudiced perception of a child, and Lowry expressed it in a style which has some of the naive directness of children's drawings. But it could not have been made without a remarkable sense of tone, nor communicated without a feeling for oil paint. And in the end it is only a setting for Lowry's other discovery, the crowd. All those black people walking to and fro are as anonymous, as individual, as purposeless and as directed, as the streams of real people who pass before our eyes in the square of an industrial town. They are observed without prejudice or comment, yet with a certain sympathy. An outside observer would have slipped involuntarily into satire or indignation. Lowry, who is one of them, takes them for what they are, and for that reason gives posterity a picture of industrial society much truer than they will receive from writers with a romantic commitment. But, of course, posterity will pay attention to him only because he is a genuine artist, who first responds to what he sees, irrespective of what it represents, and then broods sympathetically on the result.

Reproduced with Lord Clark's permission from "A Tribute to L. S. Lowry", Monks Hall Museum, Eccles, November 1964.

Lord Clark

Lowry can give significance to things by leaving space around them. A full exhibition of his work should dispel the idea that he is just another self-taught "Primitive" with a passion for industrial archaeology. He is a bigger man than that. He has painted not only cities but fields and cottages and seascapes. Over all his work broods a menacing melancholy. He is the painter of loneliness.

The loneliness of Lowry doesn't make one shiver. It exults in the vastness of our surroundings.

Sir John Betjeman

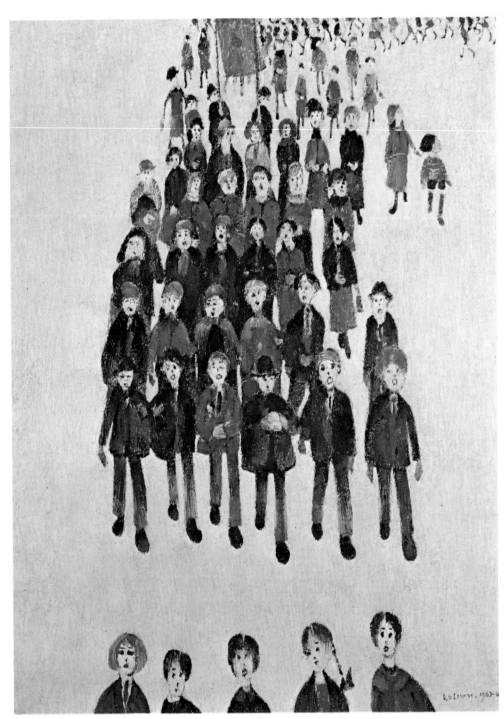

145 Whit Walk 1962

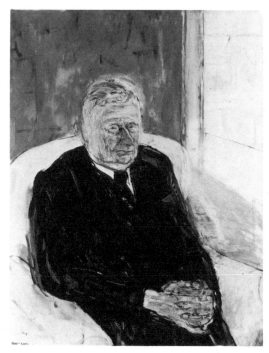

Olwyn Bowey RA Portrait sketch of L. S. Lowry 1963-64

My portrait of L. S. Lowry was painted whilst he was on one of his fairly rare visits to London, when he came to Mervyn Levy's flat in Sheen for a couple of weekends and amiably agreed to sit there for me. To break the ice at first, we did have in common the fact that I came from Stockton-on-Tees, a part of the North he knew well and liked very much, so we enjoyed recalling the odd and endearing street names that crop up in old towns, and remembered with affection Finkle Street, in an old industrial riverside port long since demolished.

Names intrigued him and pleased his great sense of the ridiculous – and served to kindle his special sort of imagination; I remember at that time in the sixties, many pop groups were mushrooming, and their collective group names greatly amused him – he kept himself awake after lunch for some time thinking up new names – Dave Rubbish and his Bins being one favourite.

As time was short, and I hadn't thought in the first place about any particular setting, he suggested I paint the empty background bright red – it was probably the first colour he thought of to cheer it up – but I said I hadn't the courage, and handed him the brush jokingly, whereupon he painted most of it in for me. I remember that he was really surprised at my using nothing else but No. 6 sable brushes to paint a whole picture; the portrait itself he didn't bother about at all – as he said, he had no idea what he looked like nor had anybody come to that – it was all quite immaterial to him beside "those little brushes" I used.

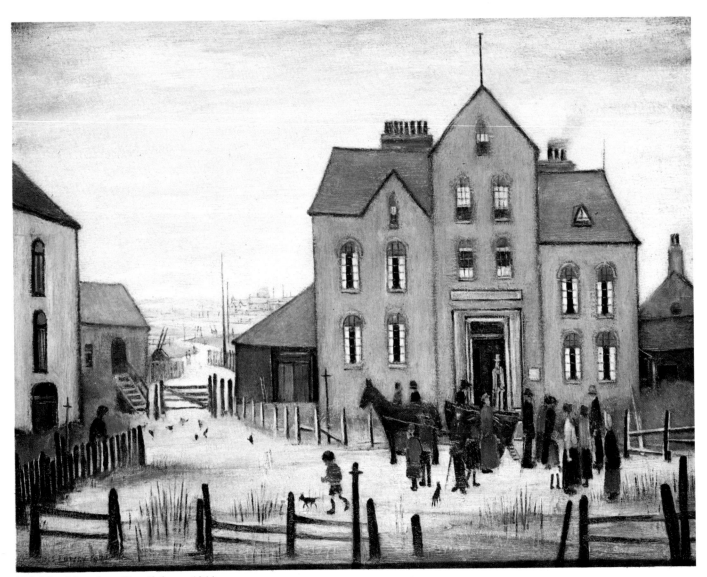

155 The Mansion, Pendlebury 1944

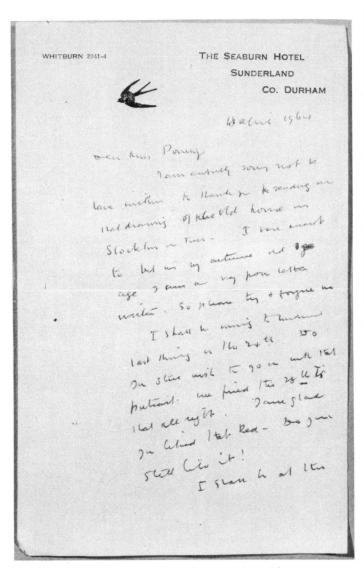

Letter from L. S. Lowry to Olwyn Bowey, RA, making
arrangements to sit for the portrait (*illustrated on page 23*)
referred to in Miss Bowey's tribute

At the end of the afternoon he heaved himself out of the chair to find he had been
sitting on a drawing pin. "I thought there was something" he said with great satis-
faction, "but we mustn't disturb the artist must we?"

I feel that the accompanying letter [illus. above] written from Sunderland, which he
loved to visit and just look at things, is very typical of him somehow, even to the
printed swallow on the hotel note-paper – and it always helps me to recall painting the
portrait with affection.

Olwyn Bowey

Tributes continued on page 31

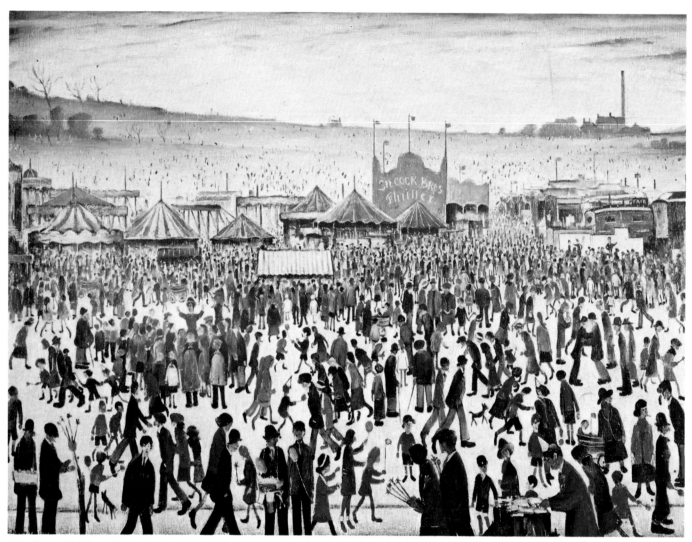

166 Good Friday, Daisy Nook 1946

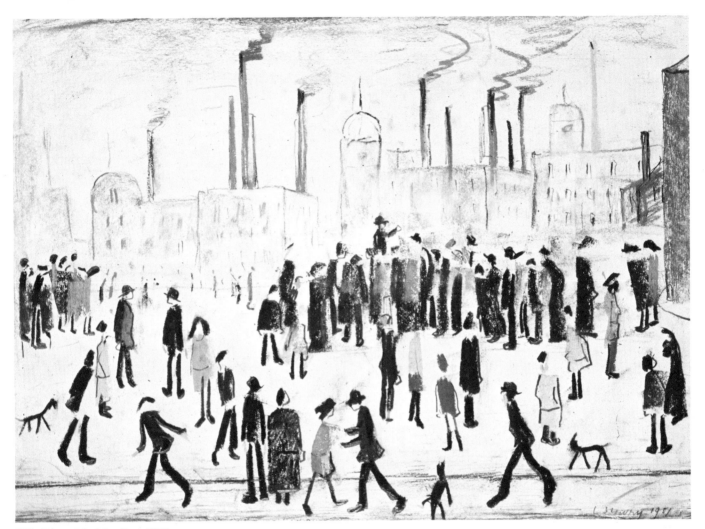

193 Open Air Meeting 1951

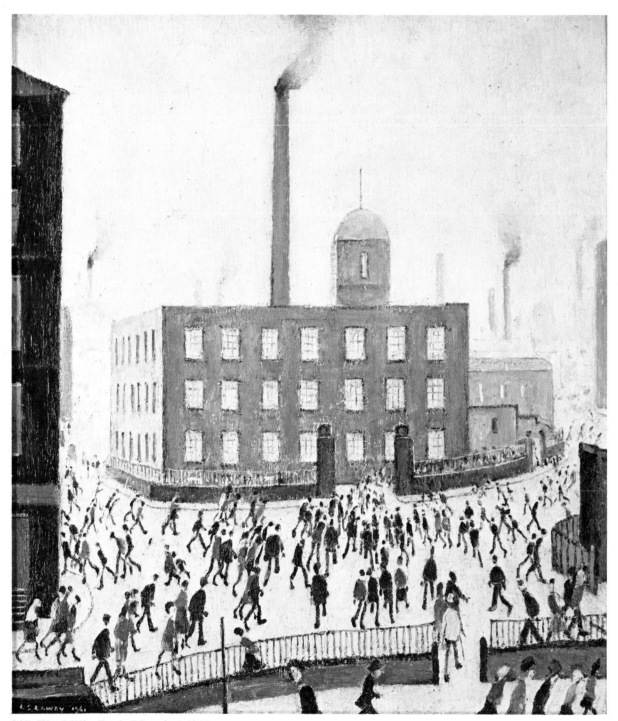

267 The Mill – Early Morning 1961

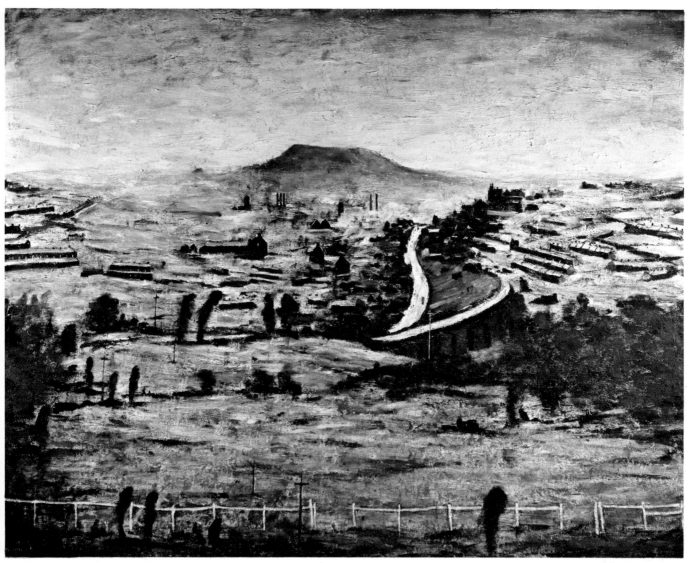

298 Bargoed 1965

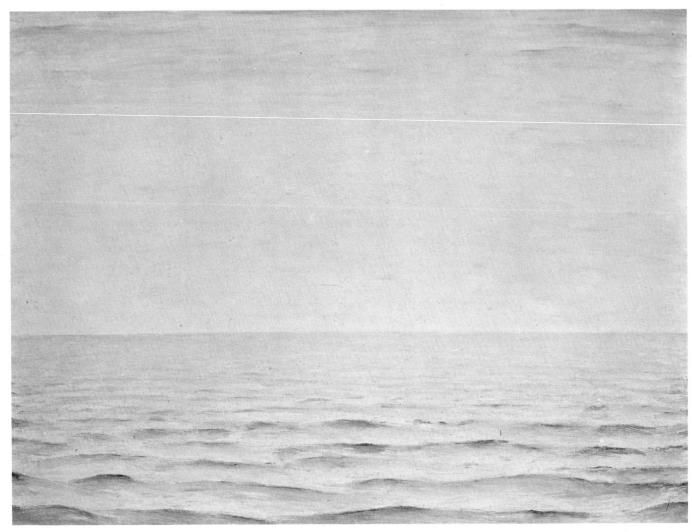

306 Grey Sea 1966

When I first knew Lowry during the first World War he was a long, thin gangling figure, with boots that always looked too big and oddly articulated limbs that seemed to have been assembled by someone not quite sure of themselves. Many years later, when I had become familiar with the odd idiosyncratic figures that populated his canvases, I realised how very like they are to himself.

There is a motivation in the manipulation of paint and in the selectivity of composition as personal as the way in which a painter walks and talks and many painters reflect themselves and develop more easily within the intuitive limits nature has imposed upon them rather than the scholarship of accumulated knowledge. Lowry's simple life style and lack of the more obviously worldly ambitions insulated him from many of the hazards and limitations encountered by more superficially gifted contemporaries and enabled him to develop this intuitive talent.

From the age of fifteen, along with Lowry, I attended the evening classes at the Manchester School of Art, almost every night in the Life class. With the arrogance and maturity of sixteen years I regarded him, at the age of thirty, as an old man. At this advanced age any promising future must be well behind him and there could be little more prospect than the degenerative progress of old age. Years later, recalling those early days I mentioned that I never remembered him painting anything remotely resembling the industrial landscape for which he became so well known. "No, Jim," he said, "I never really painted one until I was forty-five." I think it was at this point that he achieved that fusion and identity with his subject that enabled him to paint with such authority.

At this time, during the week, he had a clerical job with an estate agent but on Saturday afternoons we often went out with our sketch books to Heaton Park and down the Oldham Road. One day, meeting in the familiar Manchester deluge, he suggested that we go to the theatre. Thinking that we were going to improve our minds I assumed that we were going to see Miss Horniman's Repertory Company at the Gaiety Theatre – then playing Ibsen's "Ghosts" – I really should have known better.

We got on a tram and he took me to the Hulme Hippodrome, a Music Hall in the poor part of Manchester, to see Fred Karno's Company in the *Mumming Birds*, a show which might have inspired The Goons and the Crazy Gang and which pulverised Lowry with laughter. I have been told that we might even have seen Charlie Chaplin in this performance. He was an original member of this company but I think he must have left by this time.

I've always associated this incident, which I'm sure struck a sympathetic creative chord in his nature, with many of the odd and lonely figures he created. They have

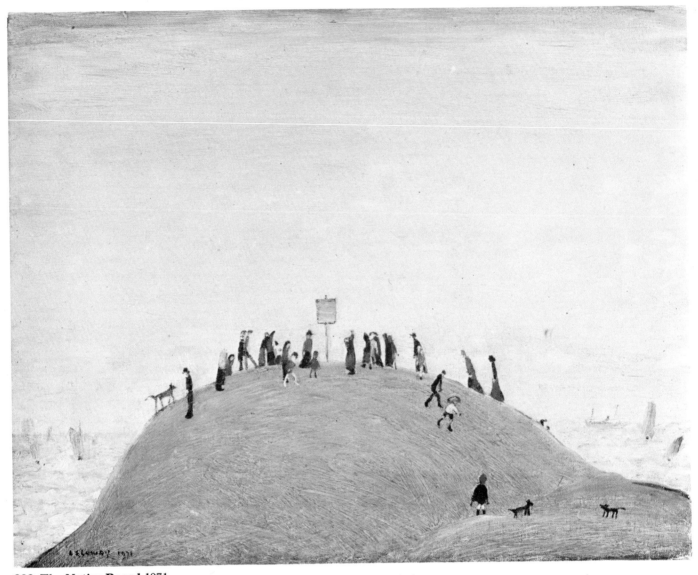

323 The Notice Board 1971

more affinity with Chaplin than with say, Bosch or Bruegel. The paintings of Rembrandt, he said, made him feel uncomfortable, understandable in this context and a characteristically honest criticism.

To the Life Master, M. Adolphe Valette, Lowry was a bit of a problem. Valette's mixture of fractured English and French was often difficult to follow and he would sit in silence on Lowry's donkey and make a small demonstration drawing on the side of the paper showing, perhaps, the balance of a figure or the construction of a hand in an effort to instil the principle of draughtsmanship on which he had been brought up as a disciple of Degas. After a while he must have realised the futility and hopelessness of trying to drive this talent from Paris to Pendlebury. Native resistance proved too strong and he would content himself by a friendly nod and a pat on the shoulder as he went by.

There is no rigid way of teaching or definitive way of making a good drawing. Artists often develop in an odd and oblique way, thriving on their own specific form of nourishment. Valette being a good teacher and a sensible man helped him to develop from within by sympathetic encouragement rather than by compounding his failures. Fortunately he was never able to teach him to draw or to observe with that accepted form of visual accuracy which had been the basis of his own development and skill, otherwise he might have ended by drawing as well as Degas, which would have been a triumph of skill perhaps but would have been a wasted talent.

Since the death of his mother in 1939 he lived alone, but he was no more a lonely and isolated character than many people who are surrounded by a large family. He had the rare gift of communication, his paintings need no explanation and speak for themselves. In spite of the unlikely subject matter, dreary looking characters wandering around nineteenth century industrial slums, he achieved the distinction of being one of the most popular painters in the country.

I went with him one day to a Bond Street Gallery showing his work. We were greeted by an enthusiastic proprietor to tell him that a large painting had just sold for a record price of £5,000. Lowry looked rather glum; this didn't seem to be his measurement of success. When I challenged him later in the afternoon with this frigid attitude he said. "Well, it's all come too late . . . if it had come thirty years ago it might have made a difference . . ." I very much doubt it! He never had the problems of fighting off those temptations and vices which would perhaps have enriched his life but which would have limited the simplicity of outlook with which he was so much involved. To know your own strength and limitations often compensates for the lack of the more positive virtues. A more catholic outlook would not have made him a better artist but only made him a different kind of man.

He died in February 1976 leaving no immediate relatives. The simple service was attended by a few friends but it was unlike the typical Lancashire funeral I had come to expect, the ceremonial affair culminating in the high point of the funeral tea. Boiled ham, potted meat and lugubrious, reminiscing relatives. In a melancholy mood I spent the rest of the day in a nostalgic pilgrimage wandering down the Oldham Road, the source of his inspiration and of the visual detail he built into the composi-

tion of his paintings. The gap of fifty years was devastating; it was now unrecognisable. No longer the rows of houses, which in retrospect seemed so warm and comforting, now replaced by monolithic faceless blocks. They seemed an anachronism, conceived like an ant hill designed to house those thousands of workers who used to get up at 5 o'clock in the morning, rather than the enlightened workers in a welfare state. Even the mills had disappeared, leaving only the factory chimneys standing in the isolation of an area looking like the paintings of Paul Nash of the Flanders battlefields, dismembered tree trunks standing in a wilderness of potholes and rubble. It seemed to me that the cemetery I had just left was more comforting and I realised that I had not only come to Lowry's funeral but to the wake of that industrial era he had chronicled with such sympathetic authority and conviction.

James Fitton

Lowry was in London for a one man show in the early sixties and Mervyn Levy had invited me to his house in Holland Park to meet the old man.

After supper and a gentle and amusing evening with Lowry making several downright and honest comments about art, life and death in general, I offered to drive him back to his hotel. As we drove along Bayswater Road I said "You know, Mr. Lowry, many artists have been made famous by art critics and newspaper publicity and so forth, but I think the truly great ones are those who are loved and respected by the painters of their time. How marvellous for you to know that you are so loved and respected."

There was a long silence and then he said "Pull up – pull into t' kerb." I was afraid that perhaps I had hurt his feelings.

He said "Say that again Lad."

I said "Surely you do realise that painters hold you in great esteem because they love your work and so they love and respect you – and I think that that is great."

He began to cry. I sat still wishing I hadn't hurt the old man's feelings.

After a minute or so he pulled out a huge handkerchief – blew his nose loudly and said –

"That's one of the loveliest things anybody's said to me for a very long time. Now drive on Lad."

I dropped him off at the Waverley Hotel and watched the tall, rather lonely figure go through the door.

Bateson Mason

In 1944 I wrote to Mr. Lowry inviting him to show in our Manchester Ballet Club Spring Exhibition, because we needed a leavening of mature, high quality work to raise our standard.

His immediate response extended subsequently into keen involvement in all our activities over the next decade; and for our 1945 catalogue foreword he wrote ". . . There is a need in Manchester for a Gallery where the Younger Generation with new ideas and outlook, is offered opportunity to exhibit work. The function of your Gallery is to offer Youth this opportunity." This, from a man of fifty-seven, largely ignored in his own locality, is some indication of his artistic integrity and generous nature.

The following year, when Ned Owens and I moved to the Mid-Day Studios, Mosley Street, a gallery in the city centre, he found it a haven where he could drop in, sure of a warm welcome, to talk painting with kindred spirits. Our ambition of presenting a Lowry One-Man Show was fulfilled in 1948 when Lefevre Gallery sent us a comprehensive exhibition. The art critic, Eric Newton needed no persuasion to open it and gave a radio talk on Lowry's work. To everyone's astonishment, including Lowry's, we sold briskly. Thus was Lowry resoundingly honoured in his own town at last.

During these years he roamed the streets, a solitary, detached observer, his notebooks crammed with sketches, whilst we marvelled at his resulting paintings; at his intuitive composition and skilled use of deliberately restricted colour; at the painstaking craftsmanship that went into the creation of each work; and, above all, at his unique vision.

No one attempted plagiary. No Lancashire School, Lowry-style, sprang up. His strong influence was his example of the professional approach to painting; of knowledge acquired the hard way at Art School, coupled with continual observation and industrious application. He was happy to give his time and attention to the encouragement of sincere young painters, and had absolutely no patience with the modish or pretentious. He had a very personal sense of humour and of the ridiculous, and was our most valued companion.

When our lease expired in 1951 he painted the large 20″ × 30″ oil, "Mid-Day Studios, Manchester" for our nostalgic closing exhibition. Across the foreground towards his basket, trots Christopher, the Dachshund, whom Lowry found exceedingly comical; they would engage in staring-matches, which always terminated with either a salvo of barking from Christopher, or a great roar of laughter from Lowry, according to which of them won.

Behind Lowry's seemingly aloof, abrupt manner, produced by sensitivity, absence of social ambition, and moods of restless melancholy, was a warm-hearted, high-principled man, whose friendship was above price.

Margo Ingham-Drake

I remember spending the best part of a week with Lowry in the mid-60's, being shown *his* Manchester. I'd pick him up every morning from his grey house in Mottram, and we'd drive around all day, stopping now and again to meet people and to look for places he'd once painted. He wore a surprised expression if he found they were still standing. Because most of his subjects had already been bulldozed. He had this special love of dereliction. It gave him a fellow-feeling because he would talk of himself as a kind of derelict washed up from the depths of the 19th century. And he would talk most of the time, as a lot of lonely people do. "Had I not been lonely", he said very solemnly as I drove him home one evening, "none of my work would have happened. I should not have done what I've done, or seen the way I saw things. I work because there's nothing else to do."

That was Lowry's self-caricature. He'd got it down to a fine art by then. He was rising 80, and he could be very funny, particularly about himself. It was all designed to keep you happily at a distance, lest you should be tempted to take him seriously, which would have worried and perhaps threatened him. "I'm not dedicated, you know. Not dedicated at all", he would say.

But of course he was. Lowry was a deeply serious and dedicated man. Often he appeared to be dedicated to doing nothing, but actually he was painting away inside his head. Then sooner or later he'd be bored enough to set up a white canvas without the slightest idea what to put on it; and out it would come, the fruits of all that sitting and wandering and observing. What he liked to call the "battle of life".

Lowry pursued that battle of life like a war correspondent who's hooked on what he hates, through the wastelands of industrial England. He was a man who systematically set out to explore and record all the major industrial cities in England – the uglier the better. He would never have done it if he'd not been dedicated to his own loneliness. Lowry was right: if he hadn't been lonely he would never have seen what he saw. It gave him a vision of England, and he devoted his long life to setting it down on canvas. Blake, Martin, Dadd, Stanley Spencer: they were lonely visionaries too. Something about England seems to nurture them, and we all find it hard to place them because they swim against the prevailing currents. And that is their very strength.

Edwin Mullins

He was before everything else to me a very gentle, sensitive, and kind man. During all the years I knew him I never saw him commit an unkind act or behave, in what he would say was an ungentlemanly way.

His mannerisms and attitudes were a complete front. He liked to appear naive, when his mind was as quick as a flash. He liked to appear unworldly, but would

sometimes throw at you thoughts from Plato, John Donne, or Bertrand Russell. He liked to appear un-musical, but he played only Bellini or Donizetti opera. He liked to appear uninterested in the theatre, but recounted visits to the exciting Manchester theatre world of the 1920's and 1930's. He liked to appear uninterested in women, but he had very good eyes for a pretty girl . . . But he never appeared uninterested in money, and only took the Financial Times.

He loved football and cricket and would tell in great detail of visits to Old Trafford before the first World War, and described beautifully Billy Meredith running down the wing for Manchester United.

He was a great wit – and his dry humour was never absent even on the greyest of days. Once we went to a picture auction together, and a picture he'd sold years before for very little money was sold for quite a few thousand pounds. He was asked how he felt, and he said "like the horse must feel when they give the jockey the prize for winning the race."

Mainly an awkward man physically, he became retiring from an early age because of scorn by other children at school. It began a self-imposed isolation from other people – after his mother died he lived the rest of his life completely alone – but he wanted to. You could tell when he wanted you to go because he either fell asleep or went to bed.

He was the kindest man, giving quietly and only when he saw somebody wanted something – he was never one for impersonal gifts – neither was he one for demonstrative "do-gooding!" Always avoiding "big" occasions. It was important to him that he pursued a life showing no sentimentality; it was because he didn't want to show he felt sorry for anyone and didn't want to feel sorry for himself. He said nobody should expect people to accept his paintings because nobody asked him to do them – but his compassion was deep and broad, seeking out the people standing outside society and suffering the circumstances of that, as he did. He once pointed out a "down-and-out" to me and said, "but for a good bank-balance there go I. I wonder what makes them lose their self-respect, I think they must have a strength that allows them to give up at a certain time!" I know one day Lowry said to me "I'm retiring!" and he did! He hardly painted ever again – because he said he'd done it all – and so he would be painting for other people and not himself.

I will miss desperately our walks in Manchester and Salford, but he was tired at the end; he was ready to go, he was becoming a little afraid of the change and didn't want to see it anymore – he was a definite Victorian and loved to remember.

His work has no complications; it never has the slightest desire to confuse, because he would consider that practice worthless. He wanted to record his personal observations about life and he did it in the place he was born – and where he chose to die.

Harold Riley

It was after my first exhibition at The Beaux Arts Gallery in November 1955 that I met L. S. Lowry. He had been there with a friend, bought two paintings and asked Mrs. Lessore, the gallery Director, to arrange a meeting.

We finally met early in 1956, one lunchtime at Tottenham Court Road underground station. The one, not quite knowing what the other would look like but somehow recognising each other immediately.

It was the beginning of a long, and for me, very enriching friendship.

He asked to meet my parents and so it was arranged that he came to Cumberland. That year and almost every year afterwards he stayed with us, usually in the summer but sometimes he would arrive unexpectedly for the odd weekend – once in his carpet slippers, by taxi, all the way from Manchester.

He hung his hat and walking-stick on the railings at the bottom of the garden. He enjoyed village life, talking to the local shopkeepers, being amused by the stories and and most of all getting around the countryside and the coastal areas.

He always arranged to have a hired car from morning till evening so that we were able to get away from the beaten track. I used to paint or draw and he would, most of the time, just watch or stroll around, although when we went to the coast he drew; he also worked around Aspatria and once, in the mountains, although when I looked at his drawings at the end of the day, it was of an industrial landscape, which he had done whilst sitting facing Skiddaw.

After a day's work we would arrive back around 7 p.m. to have dinner, he was very fond of milk puddings and home-made fruit tarts. He really liked very simple food but in London was always amused by our ventures into restaurants, should I try out a more exotic meal. The usual pattern was that after dinner (Lowry always helped my mother with the dishes) we would sit and talk and finally around 2 a.m. have hot milk and ham sandwiches.

Some of the most interesting conversations I had with Lowry were at this time. He would talk about Bellini, Donizetti and Stravinsky, his favourite composers; he loved Italian opera but he also liked the *Rite of Spring*, the Restoration Dramatists – and sometimes even about painting.

He talked a lot about regional painting and was firmly convinced one could only paint the place one really knew "where one belongs". We talked of the Pre-Raphaelites, Rembrandt and Daumier, whose work he admired, although he always said he

felt Rembrandt was "too great", also about Van Gogh and Mauve. "He could paint sheep with anyone could Mauve."

Occasionally he talked about the activity of painting and once when I was going to destroy a charcoal drawing of the coast made that day because I had overloaded it, he wouldn't let me and said, "Oh no – you can always pull anything through – first wash it and work back into it", whereupon he took it into the bathroom and plunged it into a bath of water, swishing the water over it to and fro until the original structure emerged. The recurring theme in our late night conversations was Lowry's questioning whether or not his work would live and had it all been worth it.

There was a lot of laughter too. L. S. Lowry had a marvellous sense of humour and was a very keen observer.

He liked my father's stories of village life very much, one in particular which had to be repeated to him almost every time he came and he unfailingly laughed until tears ran down his cheeks as though he had never heard it before.

It was about Aspatria Rugby team playing away at Workington. The referee was from Aspatria and at one point during the game there was a free kick and some confusion as to which side it was for. When the referee was asked, "Who's the free kick for, Harry?" he replied, "For us of course".

In London, I saw Lowry frequently, we went to plays, opera and the ballet, but the play which impressed him most visually was Pirandello's *Six Characters in Search of an Author*, with Sir Ralph Richardson. When the six characters moved en bloc, very slowly, in their black Victorian clothes from back to front of stage, he was enrapt; he went to it again and again and I believe he made a series of drawings and paintings from memory later on.

The last time I saw him was in Seaburn near Newcastle when we had three or four hours together over a rather large tea in his hotel.

Again Lowry's eternal question, "Will I live? Was it worth it all?"

Without the friendship of L. S. Lowry, my life would have been infinitely poorer and his unfailing and continuous encouragement, concern and help to me with my work opened new avenues and kept me plodding on when times were bleak.

My admiration of his work was and is enormous; but also of him as a man. As a companion he was marvellously humorous, inquisitive, mischievous as a child and gentle, but he was more than that, he had great shrewdness and understanding. In short, he was unique.

Sheila Fell

For some time the Royal Academy had wanted to stage a retrospective exhibition of L. S. Lowry as a tribute by artists to its most popular member. After some hesitation he gave his blessing to the project and this was followed by a visit by the President, Sir Thomas Monnington, to Lowry's house at Mottram-in-Longdendale. Lowry had not been well but the President found him in good spirits and enthusiastic about the exhibition.

Tragically, they both died within weeks of this meeting along with one of Lowry's closest friends Mr. Leo Solomon, whose bust of the artist is included in the exhibition.

It had been agreed that I should select the work and I saw him after Monnington's visit. He was in great form, very cheerful and helpful. I was impressed when we went to a rather grand pub for lunch filled with prosperous business men. There was a sudden hush over the huge dining room and everybody turned to look at him as we made our way to our table. I felt proud that an interest generally accorded to a Pop Star was this time for a painter. His last words to me that evening were "I'm looking forward to the exhibition".

Carel Weight

On the occasion of this memorial exhibition for the late L. S. Lowry, the Royal Academy invited a number of painters, writers, critics and friends whom we knew to be in sympathy with his artistic intentions and achievements to write brief appreciations or memoirs for this catalogue. We would like to thank them all most warmly for their generous response to our request and for the many real insights into his both unique personal and artistic qualities which, we believe, these contributions so clearly provide.

Nicholas Usherwood

General Information

Dates of Exhibition:
The exhibition is open from 4 September to
14 November 1976

Hours of Opening:
10am–6pm Daily (including Sundays)
Last admissions 45 minutes before closing

Price of Admission: 60p
30p students, pensioners, group visits.
Half price on Mondays, Sunday Mornings until 1.45pm

Illustrated Catalogue:
Price £1.80 (by post U.K. only £2.30)

Season Tickets:
For one year from date of issue: £4.50
Students and pensioners £2.25

Direct admission at the officially reduced rate of 30p
(Mondays 15p) for Students, Teachers accompanying parties,
Members of Staff Associations, Working Men's or Girls' Clubs,
or similar organisations and Pensioners can be obtained at
the entrance to the Exhibition on production of a current
student or membership card, pension book or other forms of
identification.

Visitors are required to give up their sticks or
umbrellas before entering the Galleries. They can be left
with the attendants at the Cloakroom in the Entrance Hall.
The other attendants are strictly forbidden to take charge of
anything.

Invalids may use their own wheeled chairs or obtain the use
of one without charge by previous arrangement. Application
should be made to the Registry for the necessary authority.

Buffet Restaurant with licensed bar.
Open daily.
Under the management of Grants of Croydon Catering Services.
Access to the Restaurant is from the Ground-Floor.
Entrance Hall.

Catalogue Notes

In writing these notes for a selection of the exhibits I have tried
to limit myself to a chronologically well-spread commentary on
certain aspects of the artist's work and personality. The student
years, the origin of technical methods, the use of materials, the
growth of stylistic conventions and the gradual forging of a
unique personal vision, illuminated at many points by the
artist's own words are factors which I hope combine to provide
a fuller and more rounded picture of a remarkable, but always
complex genius.

M.L.

In deference to this most English of artists, dimensions are
given in inches only, height before width.

Lowry at work
Photo: John Bull

Catalogue

Adolphe Valette

**Manchester Cathedral, looking up the Irwell
from Bailey Bridge**

1910
Oil, 3¼ × 6
Lent by John Cross, Esq.

One of the crucial formative influences in Lowry's early
years as an art student at the Municipal College of Art,
Manchester, was his teacher, Adolphe Valette.
At this time, Valette, an Impressionist painter of considerable
distinction – as this painting shows – taught his version of the
style which greatly influenced Lowry, and which he would
continue to practise at sporadic points throughout his
life. Never a follower of any particular school of painting, it is
nevertheless of interest to view Lowry's version of the
Impressionist idiom as it descends via his early tutor.
Whether one is looking at one of the Lytham pastels (20, 31)
at a solitary yacht (90) or at a much later picture such as
the *Beach Scene* of 1958 (241) the influence of Valette is
powerfully evident. And even beyond the Impressionist manner
one can see in this beautiful, deeply evocative painting,
already, the makings of a Lowry. The River Irwell, the
buildings, the misty, enveloping atmosphere and diffused light,
are all elements and qualities that Lowry will use again and
again over the years.

Adolphe Valette

Cab Stands, All Saints, Manchester

1920
Oil, 3¼ × 6
Lent by John Cross, Esq.

Adolphe Valette

Castle Gate, Salford

1922
Oil, 3¼ × 6
Lent by John Cross, Esq.

Olwyn Bowey, RA

Portrait Sketch of L. S. Lowry

1963-64
Oil, 36 × 28
Lent by the Tate Gallery

Leo Solomon

L. S. Lowry, RA

1967
Bronze bust, H. 16¼ including base
Lent by the Royal Academy of Arts

**Adolphe Valette Manchester Cathedral, looking up the
Irwell from Bailey Bridge** 1910

Works by L. S. Lowry

1 *Illustrated*
Yachts

1902
Pencil and gouache, $2\frac{3}{4} \times 4\frac{1}{2}$
Lent by Mrs Ellen Solomon

Yachting scenes have always figured prominently in Lowry's work. They possess both literal and symbolic significance. Whether drawn as early as 1902, when the artist was fifteen, or as late as 1975 in his eighty-eighth year (328), they relate, both in fact and imagination, to family holidays spent at Lytham. In later years, at his mother's request, he painted the picture of *Sailing Boats* 1930 (89) which always hung in the front room of the artist's house at Mottram.

2
Still-Life

1906
Oil, 10×14
Lent by the Museum and Art Gallery, Salford

A feeling for the sheer quality of pigment is often apparent in the artist's work. In a picture such as this still-life painted in his early years as an art student he used his oil colour with a thick, rich impasto reminiscent of Courbet. The brush strokes speak a language of their own and impart to the surface body of the study qualities of texture and *matière* which he continued to use at many points in his later work.

The pleasure which he obtained from the use of his materials – whether he was working in oils, pastel, water-colour or pencil – is always communicated to the spectator.

See *Old Lady c.* 1910 (11)

3
Still-Life

1906
Oil, 10×13
Private Collection

4
Portrait of a Male Model

1908
Oil, 15×11
Lent by permission of the Executors of the late L. S. Lowry

5
Arden's Farm, Swinton

c. 1908
Oil, $7\frac{1}{4} \times 10$
Lent by the Museum and Art Gallery, Salford

See *Farm Buildings, Worsley* 1914 (17)

6
Portrait of a Man

1908
Pencil, $16\frac{1}{8} \times 11$
Lent by the Museum and Art Gallery, Salford

This is the artist's first portrait drawing from the life. At the time it was made Lowry was in his third year at the Manchester College of Art. It displays a thorough appreciation of the requirements of good, academic drawing. An understanding of form, of the anatomical construction of the head, and a more than competent ability with the pencil. Stump drawing was commonly practised at this time and it was as early as this that Lowry began to use his fingers and thumb to create the smudging and rubbing effects that he required. This technique he continued to use throughout his life when drawing with the pencil. He was a master smudger. Deft, subtle, vigorous, he could create atmosphere, turbulence, serenity, weather conditions; in fact the widest range of effects by the simple use of his fingers or thumb. "They're the best tool you've got, Sir!" he once told the writer.

Once again his debt to Valette is apparent. The strength and authority of his early art school drawings owe everything to the thorough grounding in drawing that he received from his master.

7
Head from the Antique

c. 1908
Pencil, 21×15
Lent by the Museum and Art Gallery, Salford

A drawing made during the artist's third year as a part-time student at the Municipal College of Art, Manchester. What is now clear is that L. S. Lowry was never a full-time art student. He attended evening classes at Manchester over a ten year period from 1905 to 1915. During the daytime he was employed as an insurance claims clerk and later as a rent collector and clerk (See *Introduction*).

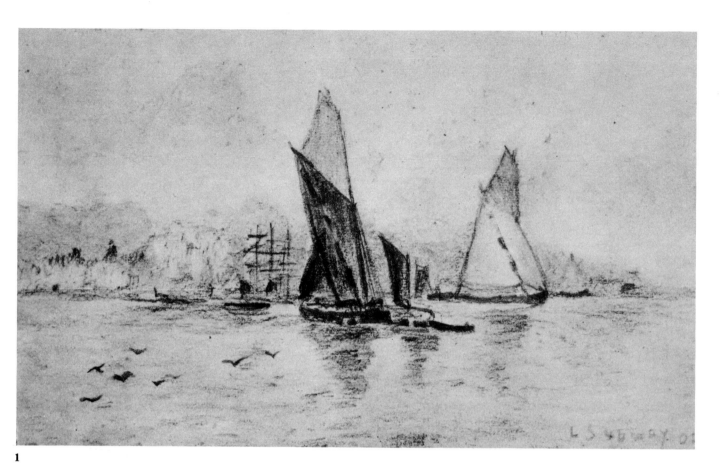

1

8 *Illustrated in colour on p. 12*
Portrait of the Artist's Mother

1910
Oil, 16 × 12
Lent by the Museum and Art Gallery, Salford

The portraits of the artist's mother and father (9) were
painted in the same year. They are competent and factual,
and were painted mainly to please the artist's parents at a
time when Lowry was struggling to master the rudiments of
academic drawing and painting as a part time student at the
Municipal College of Art in Manchester. It was in this year
also that he wrote the letter applying for a job with The
Pall Mall Property Company Ltd. (See illustration p. 53)

9 *Illustrated in colour on p. 14*
Portrait of the Artist's Father

1910
Oil, 18 × 14
Lent by the Museum and Art Gallery, Salford

The companion portrait to that of the artist's mother (8).
The disparities between colour and style presented by these

two paintings show them to be, from the artist's point of view,
experimental. In this painting the brushwork is freer and more
relaxed. The colour, notwithstanding the ravages of pollution
and cracking (the artist always refused to permit any
conservation to be carried out on either of these pictures)
is conceived in a far less realistic key.

10
Clifton Junction – Evening

1910
Oil, 8 × 14
Lent by the Museum and Art Gallery, Salford

See *Farm Buildings, Worsley* 1914 (17)

11
Old Lady

c. 1910
Oil, 20 × 16
Lent by J. Garson, Esq. (On loan to Manchester City Art Galleries)

The origins of any later, personal stylization which an artist
may evolve, and by which he becomes known – the style that

is unmistakably his own – are inevitably rooted in the formal ground-work that is the only basis for such an evolutionary process.

The formal academic skills displayed here, and in the *Still-Life* (3) painted a few years earlier, are the foundation upon which Lowry's unique vision is based.

Both pictures reveal an ability to handle paint in the best academic tradition, as well as an appreciation of traditional subject matter.

12
Heath House, Station Road, Pendlebury

1912
Pastel, $7\frac{1}{2} \times 13\frac{3}{4}$
Private Collection

In 1909 Lowry and his parents moved from Rusholme to 5 Westfield, Station Road, Pendlebury, in Salford. On the reverse of this picture is an inscription by the artist which reads "This is Heath House, Station Road, Pendlebury, opposite the house I lived in for nearly forty years."
L. S. Lowry. 7 June. 1973

In fact it was in 1948 that the artist moved from Pendlebury to The Elms, Stalybridge Road, Mottram-in-Longdendale, Cheshire where he was to live for the remainder of his life.

13
Mill Worker

1912
Pastel, 15×9
Private Collection

This delicate, tentative pastel is the first appearance of the industrial scene in the artist's work.

14
Boy in a School Cap

1912
Pencil, 17×10
Lent by the Museum and Art Gallery, Salford

A drawing of a family friend which displays the rich, velvety quality of pencil-work that was to distinguish so many of the artist's drawings of every period.

15
House in Eccles Old Road

1913
Oil, 15×12
Private Collection

16
St. Mary's Church, Swinton

1913
Pencil, $8\frac{1}{4} \times 5$
Lent by the Museum and Art Gallery, Salford

17
Farm Buildings, Worsley

1914
Oil, $9\frac{3}{4} \times 13\frac{1}{2}$
Lent by the Rev. Geoffrey S. Bennett

Between the years *c.* 1908 to *c.* 1915 the artist painted a number of outdoor subjects which display his intense feeling for the physical qualities of oil colour; a medium which he was now using with a heavy impasto. The brush-work is loose and juicy, and the technique originates in the still-life paintings of a few years earlier (3)

18
Selling Oil-cloth on the Oldham Road

1914
Oil, $11\frac{1}{2} \times 15\frac{1}{2}$
Lent by A. R. Oldham, Esq.

19
Seated Male Nude

1914
Pencil, $21\frac{5}{8} \times 14$
Lent by the Museum and Art Gallery, Salford

Drawn in the Life School of the Manchester College of Art in the artist's ninth year as a student, this study shows how well he had now mastered the subtleties of academic draughtsmanship. While there is nothing 'flash' about this, and similar drawings, the artist's deep understanding of anatomy and foreshortening belies any of the ill-informed suggestions that he was unable to draw.

20
Fishing Boats at Lytham

1915
Pastel, $15\frac{3}{4} \times 19\frac{3}{4}$
Lent by Mrs. Phyllis Bloom

Lowry used water-colour only occasionally (250) but in his early work he often used pastel. Neither medium has exerted any marked or obvious influence upon his work, although the use of pastel was a vital step in the direction of oil painting as his ultimate medium of expression. More controllable than water-colour, it provided, as here, a bridge between drawing and painting and indicated that the artist needed a colour medium that could be worked into and developed over a period.

21 *Illustrated*
Mill Gate

1916
Pastel, $12\frac{1}{2} \times 19$
Lent by Monty Bloom, Esq.

The medium of pastel drawing afforded the artist an opportunity to bridge the shift of his interest from the subjects of his earlier work – notably landscape – towards the full flowering of his awakening passion for the industrial scene.

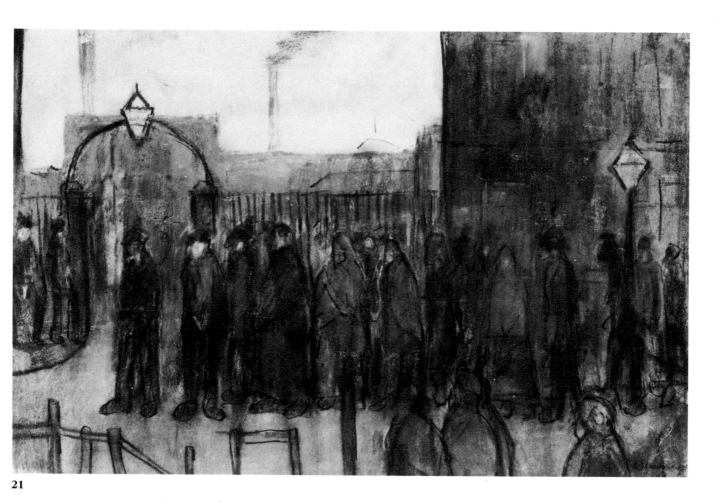

21

Pastel he had frequently used before this time when working from nature, but this, and similar studies reveal the process of exploring the possibilities of a fresh subject interest with a broad and sympathetic medium.

**22
Woman's Head**

1916
Pencil, 21½ × 14½
Private Collection

**23
Going to the Mill**

1917
Pastel, 23½ × 27½
Lent by the Rev. Geoffrey S. Bennett

An early industrial view, still hesitant in concept and execution, but already portending the coming industrial

'explosion'. It is here that the vision of the industrial landscape begins to exert its fascination for the artist. To quote Lowry himself: "When I was young I did not see the beauty of the Manchester streets. I used to go into the country painting landscape and the like. *Then one day I saw it.* I was with a man in the city and he said 'Look, it is there!' and suddenly I *saw* the beauty of the streets and the crowds".

From: *The Discovery of L. S. Lowry* by Maurice Collis, 1951.

24 *Illustrated*
Coming from the Mill

c. 1917
Pastel, 17¼ × 21¾
Lent by the Museum and Art Gallery, Salford

Another and more complex variation on the theme of Mill-workers. More intricate in construction than *Going to the Mill* (23) drawn a year or so earlier, it is still hesitant in conception and execution. It leads to the line

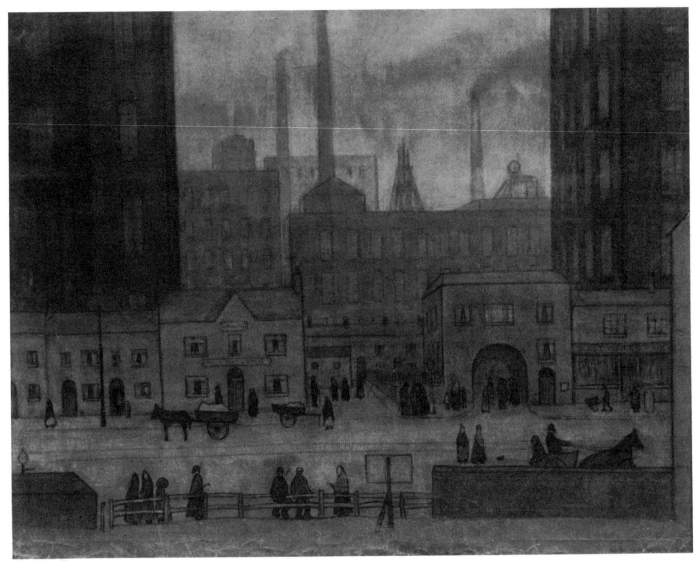

24

drawings of the twenties in which the artist was to resolve the problems implicit in these earlier compositions. (58)

25
Model with Head-dress

1918
Pencil, 20¼ × 14
Lent by the Museum and Art Gallery, Salford

As a part time art student for more than 20 years, this drawing reveals at points the artist's struggle to master the rudiments of academic draughtsmanship. The face seldom

seemed to present much of a problem, but the drawing of hands certainly did. Compare the drawing of the hands in this life-class study with those of his mother (26) drawn at about the same time. Both reflect the hesitancy and the struggle of these early years. Hands would always continue to pose something of a problem for the artist, but as he developed his more expressionist style this modest academic deficiency ceased to matter.

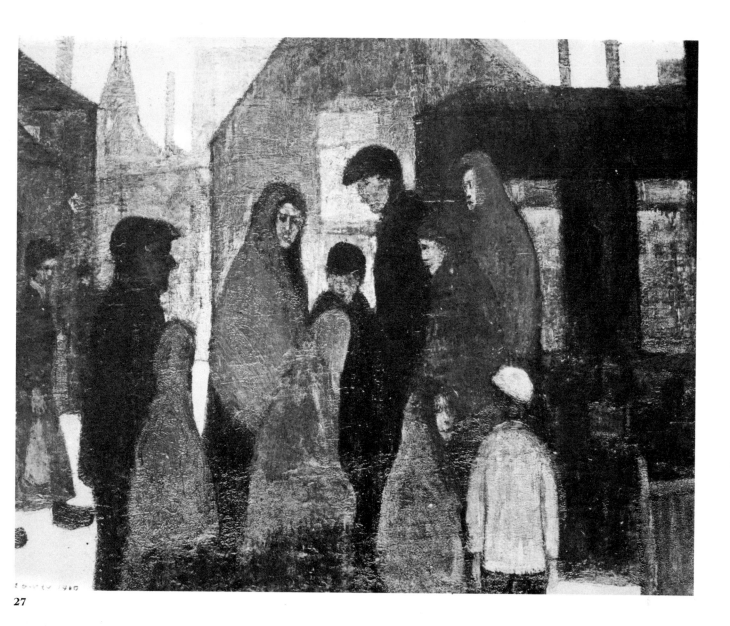

27

26
His Mother's Hands

c. 1918
Pencil, 10 × 14
Private Collection

See *Model with Head-dress* 1918 (25)

27 *Illustrated*
Pit Tragedy

1919
Oil, 15½ × 19½
Lent by the Rev. Geoffrey S. Bennett

28
Sketchbook (part)

c. 1919 onwards
Private Collection

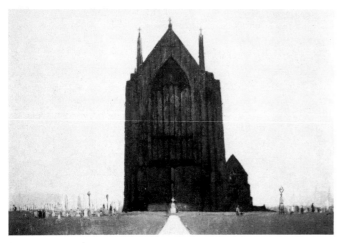

29

29 *Illustrated*
St. Augustine's Church, Pendlebury

1920
Oil, 13½ × 20½
Lent by the Rev. Geoffrey S. Bennett

30 *Illustrated in colour on p. 6*
Sudden Illness

1920
Oil, 9¾ × 17½
Lent by M. D. H. Bloom, Esq.

31
Landscape – Lytham St. Annes

c. 1920
Oil, 8¼ × 10¼
Lent by permission of the Executors of the late L. S. Lowry

32
Yachts, Lytham St. Annes

1920
Pastel, 11 × 15
Private Collection

33
Yachts

1920
Pastel, 10⅜ × 14½
Lent by the Museum and Art Gallery, Salford

See Valette's *Manchester Cathedral* 1910 (p.43)

34
Beach Scene

1920
Pastel, 10 × 14¾
Lent by John Cross, Esq.

35
Wet Earth, Swinton

1920
Pastel, 11¼ × 15¾
Lent by the Museum and Art Gallery, Salford

36
Pastoral – Lytham

1920
Pastel, 14¾ × 10½
Private Collection

37 *Illustrated*
Portrait of a Woman with Hat

1920
Pencil, 14¼ × 14¼
Lent by Mrs E. M. Taylor (On loan to Bolton Museum and Art Gallery)

38
Sketchbook

1920
8 × 5¼ (part)
Private Collection

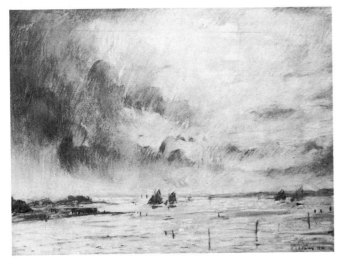

33

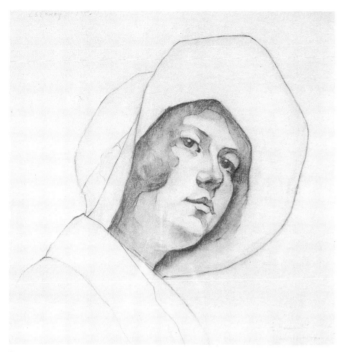

37

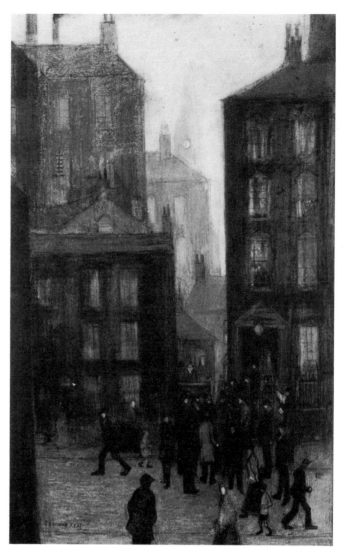

39
Whit Week Procession at Swinton

1921
Oil, 18 × 12
Private Collection

40 *Illustrated*
The Lodging House
1921

Pastel, 19¼ × 12
Lent by the Museum and Art Gallery, Salford

41
Meeting outside a Mill

1921
Pencil, 10 × 14
Private Collection

 See *A Quarrel* 1925 (58)

42
On the Sands

1921
Pencil, 10¾ × 14½
Lent by the Museum and Art Gallery, Salford

 See *A Quarrel* 1925 (58)

40

43 *Illustrated in colour on p. 8*
A Manufacturing Town

1922
Oil, 17 × 21
Private Collection

Many of the artist's greatest industrial landscapes are
"composite"; an unashamed mixing of reality and imagination.
The result is a symbolic distillation of the very essence of the
industrial scene. One can trace the same elements through a
wide range of such paintings as this. The smoking stacks, the
mills and factories with their towers and cupolas, the distant
mine-workings: figures in action, or repose. And pervading

everything, the sulphurous, viscid atmosphere heavy with pollution. For this is the apocalypse of grime which, in the twenties and thirties especially, typified the character of the industrial setting that held its occupants securely in a choking gloom.

This, like other similar paintings and drawings, is not therefore a painting of a particular town, but a composite merging of the real and the imaginary to create a visionary conception of the more brutal face of modern industrialism, as it appeared in the first quarter of the twentieth century.

44
Swinton Moss

c. 1922
Oil, $6\frac{1}{4} \times 8\frac{1}{2}$
Lent by the Museum and Art Gallery, Salford

45
Old Houses in Worsley

c. 1922
Oil, $8\frac{3}{4} \times 12\frac{1}{2}$
Private Collection

46
Factory

1922
Pastel, $9 \times 4\frac{1}{2}$
Private Collection

47
An Arrest

1922
Pencil, 14×11
Lent by Monty Bloom, Esq.

A drawing from which five years later the artist developed a similar painting (**72**). They compare, and differ in a number of respects, and illustrate perfectly Lowry's insistence that a drawing was every bit as important as a painting. In no sense is this study a mere working note for a 'finished' picture.
In many ways it is more interesting than the painting. The awesome authority of the arresting officers is dramatically suggested by their huge boots, towering figures and tiny heads. The conception is both terrifying and laughable. In the painting, however, the expressionism of these figures is considerably modified, the shawled women are absent, and the whole tempo of the conception is reduced.

48 *Illustrated*
The Rent Collector

1922
Pencil, $14\frac{1}{2} \times 10\frac{1}{2}$
Lent by Bruce Sharman, Esq.

At the time this drawing was made, the artist was collecting rents for the Pall Mall Property Company, Manchester, with

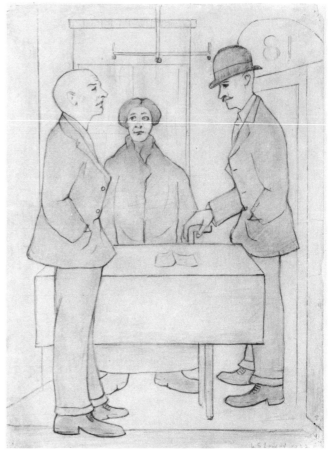

48

whom he had been in full employment since 1910. He remained with this firm until his 65th birthday in 1952 when he was retired on full pension. During his lifetime only a few close friends knew the details of his employment and, being a secretive and discreet man, the drawing, while autobiographical in essence, carefully conceals the fact that the collector on the right hand side of the picture is, of course, the artist.

49 *Illustrated in colour on p.* 11
Yachts at Lytham

1924
Oil, $15\frac{1}{2} \times 19\frac{1}{2}$
Lent by John Cross, Esq.

50
Woman in a Hat

1924
Pencil, $10\frac{1}{2} \times 8$
Private Collection

S. Westfield
Station Rd
Pendlebury
March 21st 1910.

J 36.

In reply to your advertisement in the Manchester Guardian I beg to state that I am 22 years of age. and from November 1907 to February 1910. I was with the General Accident Fire + Life Assurance Corpn Ltd, as Claims Clerk at their Branch at 20 Cross Street, Manchester. At the end of February I, along with other members of the staff, had to leave. owing to the company cutting down expenses.

I enclose herewith copy of testimonial letter, from Mr Chas A Hollin, Resident Secretary of the Branch, + which will explain fully to you the reason for my leaving.

Previous to being with the "General Accident" I was for over four years with Messrs. Thos. Aldred & Son. Chartered Accountants, 88. Mosley Street Manchester. + on my leaving them, were pleased to speak very highly of me.

I have a knowledge of shorthand + write at the rate of 60–80 words per minute

Yours faithfully,
Laurence S. Lowry.

1910

Letter of Application to join The Pall Mall Property
Company Limited, 1910
Lent by The Pall Mall Property Company, Manchester

Written by the artist in reply to an advertisement in the
Manchester Guardian. As a result the artist was taken on the
Company's strength as a Rent Collector and Clerk
(See *Introduction*)

51
Speculators

1924
Pencil, 13½ × 9½
Private Collection

52 *Illustrated*
**View from the window of the Royal Technical College,
Salford**

1924
Pencil; 22 × 15
Lent by the Museum and Art Gallery, Salford

The drawing stands at the pinnacle of the artist's achievement
with the pencil. It is a key masterpiece. The three classical

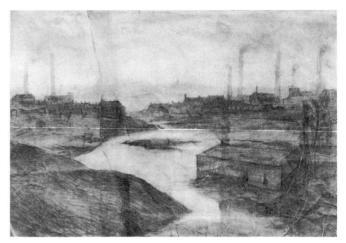

53

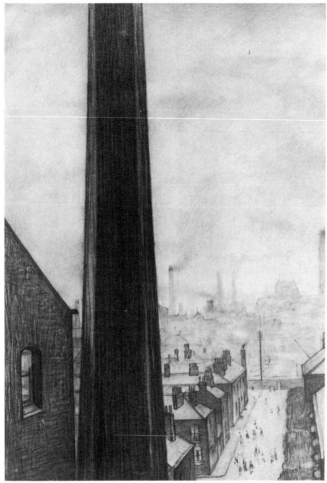

52

53
The River Irwell at the Adelphi

1924
Pencil, $14 \times 21\frac{5}{8}$
Lent by the Museum and Art Gallery, Salford

54
Men at a Meeting

c. 1924
Pencil, $14\frac{1}{2} \times 10\frac{3}{4}$
Lent by the Lefevre Gallery

55 *Illustrated*
Self-portrait

1925
Oil, $18\frac{1}{2} \times 10\frac{1}{2}$
Lent by the Museum and Art Gallery, Salford

Painted in the artist's thirty-eighth year, this is an
accomplished, purely factual record of the artist's appearance
at a time when he was still unrecognised. He is seen here in
two of his favourite articles of attire, a cap and an old raincoat.
He continued to wear these same garments well into the last
years of his life.

56
Wigan Landscape

1925
Oil, 16×16
Private Collection

areas of space – foreground, middle-distance and background –
are rendered with a surpassing strength and subtlety, moving
from the magnificent, rich, velvet tones of the foreground,
through the half-tones of the succeeding area of space in which
are set the houses and figures, to the soft, melting far distance
contained in a shimmering haze of industrial smoke. Volume,
space and atmosphere are created with powerful strokes of the
pencil, and deft finger and thumb smudgings, a technique
which derived from the artist's work in the antique and life
classes of Manchester College of Art. Consider the literal
drawing of the buildings and, by contrast, the impressionistic
rendering of the figures. The composition is stunningly daring
and the whole work a synthesis of every shade of technical
mastery from tightly controlled, to brilliantly free, loose
drawing.

55

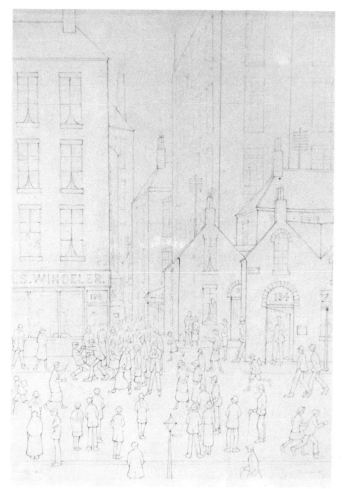

58

57
Street Scene

c. 1925
Oil, 15⅝ × 18⅞
Lent by the City Art Galleries, Sheffield.

58 *Illustrated*
A Quarrel

1925
Pencil, 13¾ × 10¼
Private Collection

The line drawings of the 1920's, composed with a coolly
mathematical precision are of the greatest significance. It is in
these studies (see *Meeting outside a Mill* 1921 (41) and *On the
Sands* 1921 (42)) that the artist began the process of structuring
his compositions with the architectural majesty that would
lead directly to the great industrial landscapes of the forties and
fifties. (182, 184, 197, 202) In these drawings one can also observe
the skill with which the artist began to solve the complex

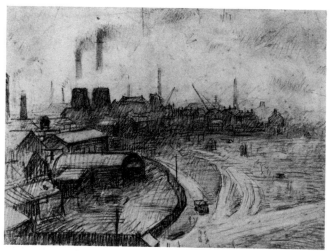

59

problem of relating figures in the mass, both to each other and to their setting. The theme of quarrelling figures appears again in *A Fight* (109) painted in 1935. There is also a characteristic touch of humour in the shop signboard.

59 *Illustrated*
View from the Window of the Royal Technical College, looking towards Broughton

1925
Pencil, $10\frac{1}{2} \times 14\frac{1}{2}$
Lent by the Museum and Art Gallery, Salford

60 *Illustrated*
Rounders

1925
Pencil, 8×15
Private Collection

60

61
Pendlebury

1925
Pencil, $10\frac{1}{8} \times 14\frac{3}{8}$
Lent by the Cecil Higgins Art Gallery, Bedford

See *The Meeting* 1928 (81)

62
Old Farm in Pendlebury

1925
Pencil, $9\frac{3}{4} \times 13\frac{1}{2}$
Lent by the Museum and Art Gallery, Salford

63
Lancashire Street Scene with Figures

1925
Pencil, $14 \times 9\frac{5}{8}$
Lent by the Whitworth Art Gallery, University of Manchester

64
The Flat Iron Market

1925
Pencil, $10\frac{1}{2} \times 14\frac{1}{2}$
Lent by the Museum and Art Gallery, Salford

65
Rhyl Sands

1925
Pencil, 5×8
Private Collection

Throughout his life the artist was attracted by the sea and the seaside. At first there were the boats and yachts at Lytham St. Annes. In 1925 he spent a holiday at Rhyl in North Wales where he made a number of drawings. Later there were the bustling and crowded scenes on the sands (*On the Sands* 1943 (142)); the ships at South Shields, and finally, in later years, the magnificent, empty seascapes, desolate and lonely in their bleak, rolling infinity.

66
Bridge with Figures over Colliery Railway

c. 1925
Pencil, 15×22
Lent by the Museum and Art Gallery, Salford

67 *Illustrated*
Northern Hospital
1926

Oil, $17 \times 20\frac{3}{4}$
Lent by Mrs F. G. Hewit and Miss E. M. Hewit (On loan to the City of Manchester Art Galleries)

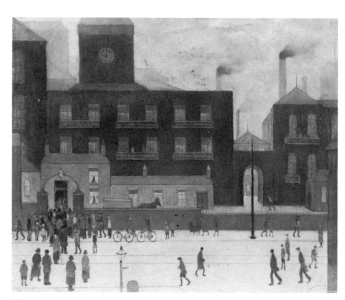

67

68
An Accident

1926
Oil, $14\frac{1}{4} \times 24$
Lent by the City Art Galleries, Manchester

The painting is based on an incident witnessed by the artist in Pendlebury when a crowd gathered around the body of a woman who had drowned herself.

The painting was bought by the Manchester Corporation in 1930 and was the first of the artist's pictures to be acquired by a public art gallery.

69
The Post Office

1926
Pencil, 11×15
Lent by the Museum and Art Gallery, Salford

The artist once asked the writer "Can you tell me, Sir, why in heaven's name does a painting cost more than a drawing? You can say just as much with a pencil!". He was perfectly right. A drawing such as this is every bit as telling as a painting. In fact it even possesses 'colour'. Consider the way in which the artist has used his tones to describe the colour of his characters' clothing. Black, argued Odilon Redon, is the purest of colours, "nothing can debauch it". And what painting could weave a more subtle sense of the industrial atmosphere, thick with smoke and grime, than this drawing with its carefully rubbed pencil-work.

One might also consider here the construction of his composition. This is a particularly good example. There are many points of interest in the drawing, but always, inevitably, the eye is led to the one point in the picture where the artist intends it to find a point of rest. This is the signboard which reads *Post Office*. The inward movement of figures from both sides of the picture carry the eye towards the central group and they, in turn, take the eye upwards to the signboard. So the spectator's interest is always locked within the picture; it cannot escape. This is the essence of great picture-making. In a much more complicated way this is what happens in a majestic composition like *Good Friday, Daisy Nook* 1946 (166) where the eye, for all its wanderings, returns, inevitably, to the circus sign: *Silcock Bros Thriller*.

70
Industrial Scene

1926
Pencil, 10×14
Lent by Mark Astaire, Esq.

71
Peel Park, Salford

1927
Oil, 14×20
Lent by the Museum and Art Gallery, Salford

One of the artist's favourite subjects. He made a number of drawings of the same subject during this period. The view is from the steps of the Royal Technical College, and the building on the left is the Public Library.

72
The Arrest

1927
Oil, 21×17
Lent by the Castle Museum and Art Gallery, Nottingham

See *An Arrest* 1922 (47)

73
Tennis Girl

1927
Oil, $9\frac{1}{2} \times 4\frac{3}{4}$
Lent by Mr & Mrs Andras Kalman

74 *Illustrated*
Dwellings, Ordsall Lane, Salford

1927
Oil, $13\frac{1}{2} \times 21\frac{1}{4}$
Lent by the Tate Gallery

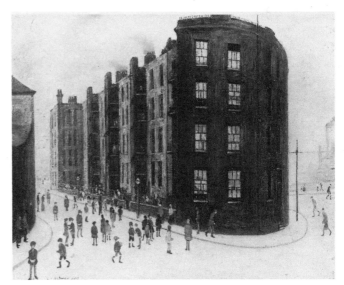

74

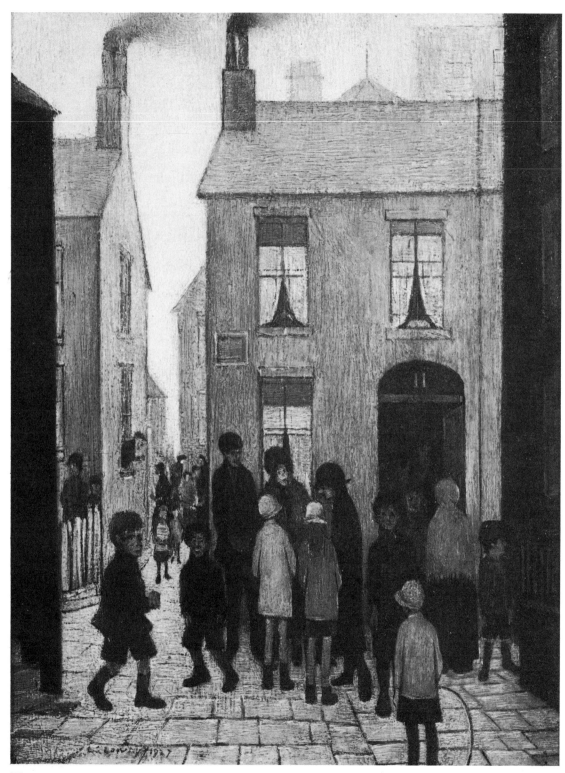

75

75 *Illustrated*
A Courtyard

1927
Oil, 16 × 12
Lent by the Lefevre Gallery

76 *Illustrated*
Coming out of School

1927
Oil, 13½ × 21¼
Lent by the Tate Gallery

77 *Illustrated*
The Terrace, Peel Park, Salford

1927
Pencil, 10¼ × 13¾
Lent by the Museum and Art Gallery, Salford

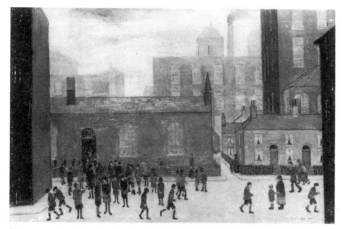

76

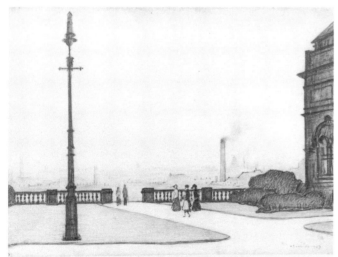

77

78
The Procession

1927
Pencil, 14½ × 22½
Lent by the Art Gallery, Oldham

79
Study for Dwellings, Ordsall Lane, Salford

1927
Pencil, 11⅛ × 15½
Lent by the Tate Gallery

80 *Illustrated in colour on p. 17*
Salford Street Scene

1928
Oil, 16¼ × 12¼
Private Collection

Before he saw man as an ant scurrying through the industrial labyrinth, Lowry saw him with a modified warmth and humanity, as here. Even so, the artist was essentially a detached observer of man and his activities, and certainly in later years a brilliant, often cruel, satirist. He was seldom concerned about people as individuals; hence his dislike of Rembrandt and that master's involvement with the individual human soul.

81
Outside the Mill or The Meeting

1928
Oil, 11¾ × 20
Lent by Mr and Mrs John Chapman

The stylization of Lowry's figures exists in two main forms. Here they are conceived as solid mass; like simple, loosely articulated silhouettes. But in some of the artist's drawings, the figure and its movement is cunningly suggested by unconnected snippets of drawing, the artist leaving gaps between the masses of the head, body and limbs. This convention is used in the drawing of *Pendlebury* (61).

It is interesting to observe – as here – that the artist never made any use of shadows. His figures cast none. He left them out as he said because "They only mess up the composition!".

Another reason for this curious convention is expressed in the writer's introduction (q.v.).

82
Witherns

1928
Oil, 11¾ × 15¾
Lent by the Crane Kalman Gallery

83
Returning from Work

1929
Oil, 17 × 24½
Lent by the Crane Kalman Gallery

The atmosphere of industrial gloom and grime which the artist creates so marvellously is achieved by a specific and carefully calculated process. Paradoxically, the basis of his oil painting is white. This may seem a curious foundation for the effect he seeks in such pictures as this. Yet there could be no better choice as it happens. The artist has always insisted that his pictures would never 'read' as he wished them to until sufficient time had elapsed for the white in his painting to 'go down' as he once put it to the writer. "Give it time to *yellow* – to darken – to discolour – and then you will see what I mean – and what it is that I want to show you . . .".

84
Hawker's Cart

1929
Oil, 21 × 16
Lent by the Royal Scottish Academy, Edinburgh

85
Greengate

1929
Pencil, 15 × 11
Lent by the Rev. Canon Gwilym Morgan

86
Building Site

1929
Pencil, 10 × 14
Private Collection

87
Swinton Schools Courtyard

1929
Pencil, 15¼ × 11
Lent by Monty Bloom, Esq.

The lamp-post is often incorporated as a prominent image in the artist's compositions. It can be seen, not only as an attractive and decorative object in its own right, adding strength and character to the pictures in which it appears, but also as an autobiographical note symbolising the loneliness and isolation of the artist as observer. An interpretation which accords well with his often repeated comments on the loneliness and frustration he frequently felt. "If I had not been lonely I should not have seen what I did!"

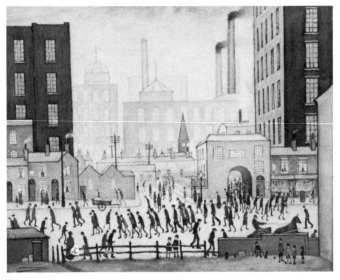

88

88 *Illustrated*
Coming from the Mill

1930
Oil, 16½ × 20½
Lent by the Museum and Art Gallery, Salford

A transitional composition leading from the line drawings of the 1920's to the more mature industrial landscapes of later years.

89
Sailing Boats

1930
Oil, 14 × 18
Lent by permission of the Executors of the late L. S. Lowry

90
A Yacht

c. 1930
Oil, 5½ × 5½
Lent by Peter Diggory, Esq.

See Valette's *Manchester Cathedral* 1910 (p.43)

91 *Illustrated in colour on p. 18*
Outside the Mill

1930
Pastel, 12½ × 19½
Private Collection

92

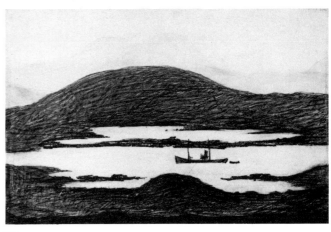

93

92 *Illustrated*
Farm on Wardley Moss

1930
Pencil, $5\frac{1}{4} \times 7\frac{1}{4}$
Lent by the Museum and Art Gallery, Salford

During 1930 Lowry was involved in the preparation of his twelve illustrations for Harold Timperley's *A Cotswold Book* (101). The drawings for this volume are executed in a tightly controlled style. But the range of the artist's technical abilities was very wide, and when he wished he could, as in this sketch, capture the essence of a subject in an extremely broad manner, working in a fast, fluent style. He could swiftly build up extensive areas of tone with sweeping smudges, and create the volume of trees and buildings with powerful thrusts and stabs of the pencil.

93 *Illustrated*
Ship towing Dinghy in the Lochs

1930
Pencil, $9\frac{3}{4} \times 15$
Private Collection

94
Crowther Street, Stockport

1930
Pencil, $7 \times 6\frac{3}{4}$
Lent by Peter Froggatt, Esq.

95
The Gamekeeper's Cottage, Swinton Moss

1930
Pencil, $10\frac{1}{4} \times 14\frac{3}{4}$
Lent by the Museum and Art Gallery, Salford

96
The Steps, Peel Park

1930
Pencil, $15\frac{1}{8} \times 10\frac{1}{2}$
Lent by the Museum and Art Gallery, Salford

97
Over the Hill

1930
Pencil, $15\frac{1}{8} \times 11$
Lent by the Victoria and Albert Museum

A drawing which by the sheer, rich quality of its pencil-work emphasises once again the remarkable way in which the artist could use pencil to suggest 'colour'. The smudging technique is extensively used and helps to add atmosphere to the sensation of colour.

Compare the style of this drawing with *Old Houses in Pendlebury* 1939 (125).

98
Crowther's Buildings, Ancoats, Manchester

1930
Pencil, 15×11
Lent by Monty Bloom, Esq.

99
Towers and Figures, Workington

1930
Pencil, $13\frac{1}{2} \times 9\frac{1}{2}$
Private Collection

100
The River Irwell from the Crescent, Salford

1930
Pencil, 11 × 15
Lent by Mrs Phyllis Bloom

101

A Cotswold Book by Harold Timperley
Lent by Mrs Marie Levy

In 1930 Harold Timperley, the author, invited the artist to make a series of twelve illustrations for his book. These were all landscape drawings in pencil. The book was published by Jonathan Cape in 1931.

102 *Illustrated on p. 20*
The Tree

1931
Oil, 17 × 23
Private Collection

103
Going to the Match

1931
Oil, 10 × 18½
Lent by the Rev. Geoffrey S. Bennett

Another version of the football theme but rendered in the Impressionist manner recalling the work of Adolphe Valette and his teaching of the method. Here Lowry employs the idiom to create a hazy sense of crowd density; of people as elements of mass, rather than as individual entities. It is "Manchester Impressionism" at its most subtle.

104
The Bandstand, Peel Park, Salford

1931
Oil, 17 × 24½
Lent by the City Art Gallery, York

105
Pendlebury Scene

1931
Pencil, 11 × 15
Lent by the Museum and Art Gallery, Salford

106 *Illustrated*
The Empty House

1932
Oil, 16¼ × 20½
Lent by the City Museum and Art Gallery, Stoke-on-Trent

The artist drew and painted a number of versions of this house which stood derelict in its surroundings. These are

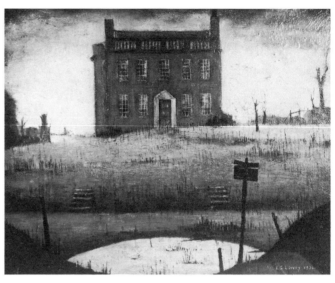

106

modified and extended quite arbitrarily. A later version, *The Island* 1942* intensifies the element of loneliness by isolating the house on an island of waste-land surrounded by a watery moat.

However interpreted, the subject is always a symbol of the artist's personal loneliness and a metaphor of universal mystery.

See *St. John's Church, Manchester* 1938 (121)

*City of Manchester Galleries (not exhibited)

107
Edward Henry Street, Rhyl

1933
Oil, 12¼ × 17
Lent by Monty Bloom, Esq.

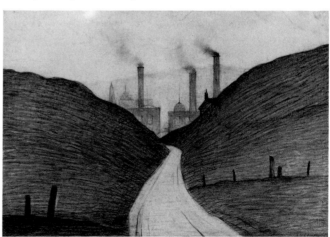

108

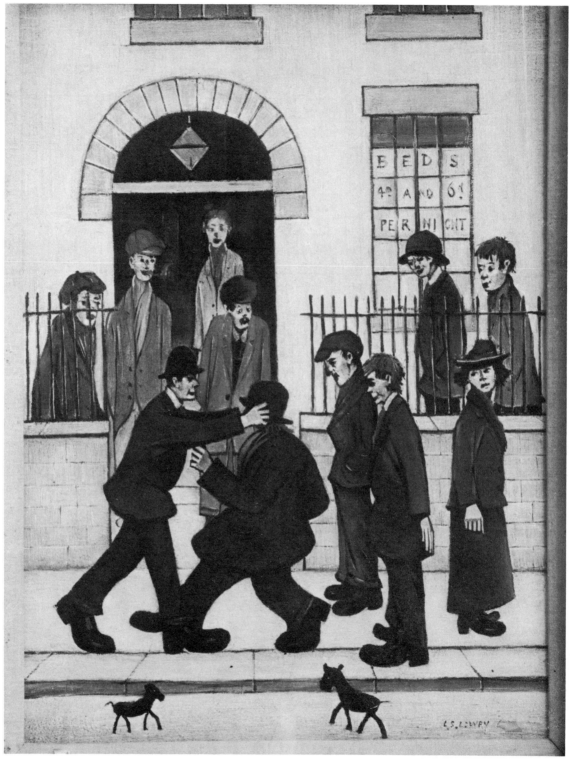

109

108 *Illustrated*
Industrial Landscape

1934
Pencil, $10\frac{5}{8} \times 15\frac{5}{8}$
Lent by the Cecil Higgins Art Gallery, Bedford

109 *Illustrated*
A Fight

1935
Oil, $20\frac{1}{2} \times 15\frac{1}{2}$
Lent by the Museum and Art Gallery, Salford

See *A Quarrel* 1925 (58)

110
River Scene

1935
Oil, $14\frac{3}{4} \times 20\frac{1}{4}$
Lent by the Laing Art Gallery, Newcastle upon Tyne

111
Street Scene

1935
Oil, $14\frac{1}{4} \times 19\frac{1}{2}$
Private Collection

112
Fever Van

1955
Oil, 17×21
Lent by the Walker Art Gallery, Liverpool

113
Berwick-on-Tweed

1935
Pencil, 12×6
Private Collection

114 *Illustrated*
Family Group

1936
Oil, $17\frac{1}{2} \times 13\frac{3}{4}$
Private Collection

This is a subject often drawn and painted by the artist.
It illustrates in particular the problem of 'communication'.
Or rather the inability of people to communicate, more
especially perhaps in the close-knit context of the family unit.
It is an essay in the language of the inarticulate. Or does it not
pose the question – *is* there anything to communicate? The
subject strikes both sociological and personal notes; indicating
the eternal isolation of the individual both in relation to
himself and to the community in which he is always so

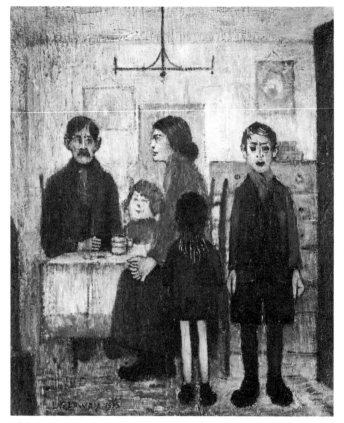

114

precariously suspended. A distinct sense of tension and
unease pervades the picture. Lowry was a master of
'expressionism'. Not in any official sense, not within the
context of the European Expressionist Movement; but
naturally and intuitively. He frequently used his own process
of distortion as here to heighten the psychological impact of
his images.

115
The Doctor's Surgery

1936
Oil, $15\frac{1}{2} \times 21$
Private Collection

116
Laying a Foundation Stone

1936
Oil, 18×24
Lent by the City Art Galleries, Manchester

117
A Manchester Man

c. 1936
Oil, 21 × 17
Lent by the Crane Kalman Gallery

Painted at about the same time as the *Head of a Man with Red Eyes* 1938 (122), the subject is virtually identical except for the disguise. Michael Shepherd in a recent deeply sensitive appraisal of the artist's work* sees this mysterious portrait in a revealing light. He writes "Disguised with bowler hat, walrus moustache and wing collar, the powerful, stylised face gazes out, with eyes slightly lifted heavenwards. Its affinity is immediately recognisable; it is the Romanesque Christ, who gazes into our soul with a penetration beyond words. Here the eyes are a little raised; man fiercely questioning his self or his god on the 'how' of his existence". It is a definition which tallies exactly with the artist's state of mind at this particular point in his life and is, of course, like the man with red eyes, a self-portrait.

**Putting Lowry in Perspective*: Sunday Telegraph, 30 May 1976

118 *Illustrated*
The Birthplace of Lloyd George

1937
Oil, 6 × 8½
Lent by Fred Uhlman, Esq.

119 *Illustrated*
The Steps at Wick

1937
Oil, 16½ × 20
Private Collection

120
The Haunted House

1937
Pencil, 10¾ × 15½
Lent by Mr and Mrs Andras Kalman

121 *Illustrated*
St. John's Church, Manchester

1938
Oil, 12 × 11½
Lent by the Rev. Geoffrey S. Bennett

Lowry possessed a remarkable facility for investing isolated buildings with a mysterious presence, conferring upon them

118

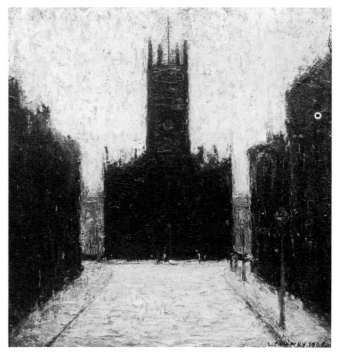

121

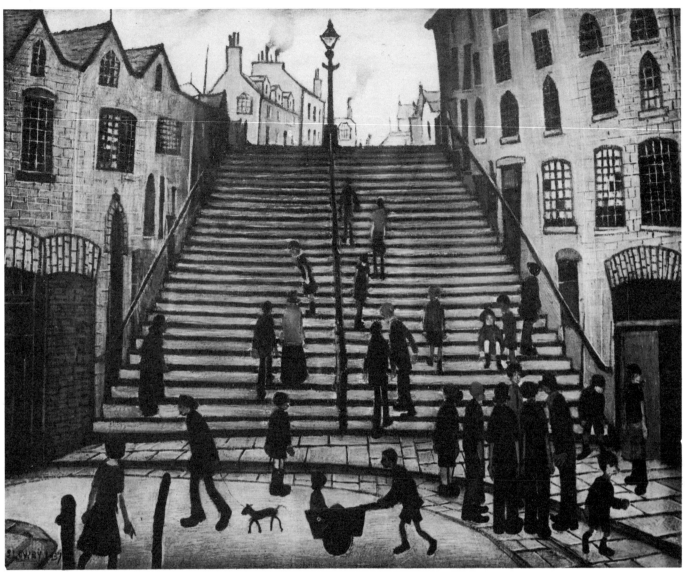

119

an almost tangible aura of brooding watchfulness, as though the building rather than the spectator was the real observer. This is one of many such pictures which brood over their surroundings like sphinxes, or the chimeras of the symbolist painters.

In fact these images can be construed as powerfully symbolist in essence, and indicating the element of eternal mystery which is always close to the parochial activities of daily life.

See *The Empty House*, 1932 (106)

122
Head of a Man with Red Eyes

1938
Oil, 20 × 16⅛
Lent by the Museum and Art Gallery, Salford

In all but title this can be seen as a self-portrait painted at a time when the artist was deeply perturbed by his mother's illness. She was to die only a year later in 1939.

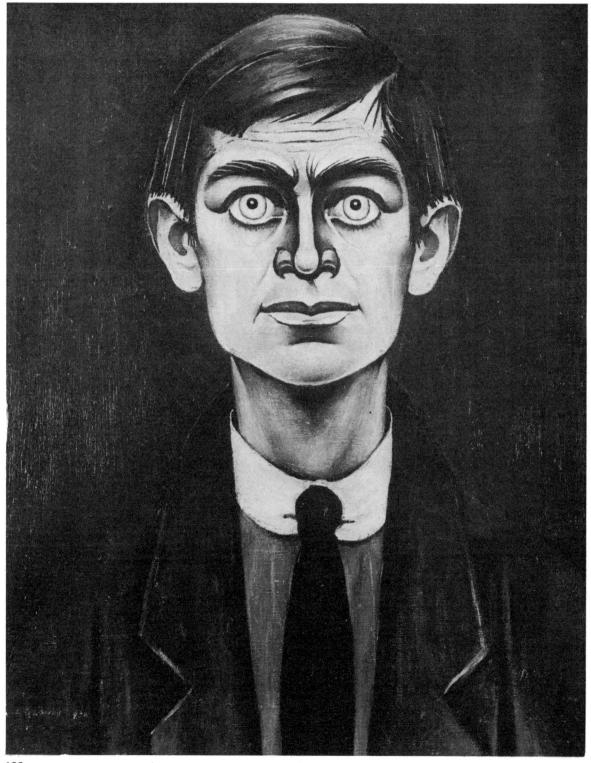

123

It was painted under great emotional stress and is plainly a cry of blind anguish: an image of isolation and suffering, profoundly and deeply introspective. The human soul momentarily suspended in the vacuum of absolute *angst*.

It also marks the precise point of Lowry's retreat from any personal involvement with other human beings. From this time onwards he would grow less interested in the individual personality of people, towards whom in his later work – the drawings especially – he would display a penetrating hostility. Three drawings clearly illustrate this point.

See *Lady in a Straw Hat without a Dog*, 1964 (297)
Man Fallen down a Hole, c. 1968 (317)
Going to the Match, 1968 (316)

123 *Illustrated*
Self-portrait

1938
Oil, $20\frac{1}{2} \times 16\frac{3}{4}$
Private Collection

See *Head of a Man with Red Eyes* 1938 (122)

124
Peel Park, Salford

1938
Pencil, $14 \times 9\frac{3}{4}$
Lent by Austin McCracken, Esq.

125
Old Houses in Pendlebury

1939
Pencil, $10\frac{1}{2} \times 14$
Private Collection

See *Over the Hill* 1930 (97)

126
Hot Potato Cart

1940
Oil, 17×21
Private Collection

127
Rising Street

c. 1940
Oil, 23×28
Lent by J. Delaney, Esq.

A shapeless composition which by this fact alone captures the soullessness of the subject. The people are ants, the houses, devoid of character, repeat their tedium to infinity. A relentless comment on the urban landscape of our time.

Only the appearance of the *Contraption* trundling across the foreground adds a note of eccentric interest to the scene.

128
Barges on a Canal

1941
Oil, $15\frac{5}{8} \times 21$
Lent by the Art Gallery and Museums, Aberdeen

129
Our Town

1941
Oil, 18×24
Lent by the Art Gallery, Rochdale

130
Saturday Afternoon

1941
Oil, $17\frac{1}{2} \times 23\frac{1}{2}$
Lent by the Lefevre Gallery

131
Waiting for the Shop to Open

1941
Pencil, 11×15
Lent by the Whitworth Art Gallery, University of Manchester

132
Piccadilly Blitz, Manchester

1941
Pencil, $9\frac{7}{8} \times 13\frac{1}{2}$
Lent by Austin McCracken, Esq.

133
River Scene

1942
Oil, 18×25
Lent by the Museums and Art Galleries, Glasgow

134
After the Blitz

1942
Oil, $20\frac{1}{2} \times 16\frac{1}{2}$
Private Collection

One of the artist's rare war paintings. It was made soon after an air-raid on Manchester.

See *Going to Work* 1943 (141)

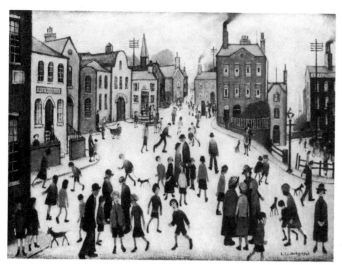

136

135
The Crime Lake

1942
Oil, 17½ × 23½
Private Collection

A popular bank holiday locality between Droylsden and Failsworth, and close to Daisy Nook.

136 *Illustrated*
A Village Square

1943
Oil, 18 × 24
Lent by the Museums and Art Galleries, Glasgow

137 *Illustrated*
Punch and Judy

1943
Oil, 15½ × 21½
Lent by the Rev. Geoffrey S. Bennett

138
Britain at Play

1943
Oil, 18 × 24
Lent by the Usher Gallery, Lincoln

139
Salford Street Scene

1943
Oil, 15¾ × 11½
Lent by the Crane Kalman Gallery

140
Bridge over Canal with Chimney

1943
Oil, 21 × 11½
Lent by J. P. Jacobs, Esq.

141
Going to Work

1943
Oil, 18 × 24
Lent by the Imperial War Museum

Lowry seems to have been fairly disinterested in the Second World War. Apart from a few drawings and paintings of the Manchester Blitz, *Going to Work* is a rare war subject. It was officially commissioned in 1942 and apart from the artist's somewhat grudging condescension to include a couple of inconspicuous barrage balloons, it might just as well have been called "Going to the Match".

142
On the Sands

1943
Oil, 12½ × 24
Lent by Edgar Astaire, Esq.

143
July, the Seaside

1943
Oil, 26¼ × 36½
Lent by The Arts Council of Great Britain

144
Old Houses, Berwick

1943
Oil, 17½ × 21
Private Collection

145 *Illustrated in colour on p. 22*
Whit Walk

1962
Oil, 24½ × 18
Lent by J. P. Jacobs, Esq.

146
Stockport Viaduct

1943
Pencil, 14 × 10
Lent by Peter Froggatt, Esq.

147
Bridge over Canal

1943
Pencil, 12 × 11½
Lent by J. P. Jacobs, Esq.

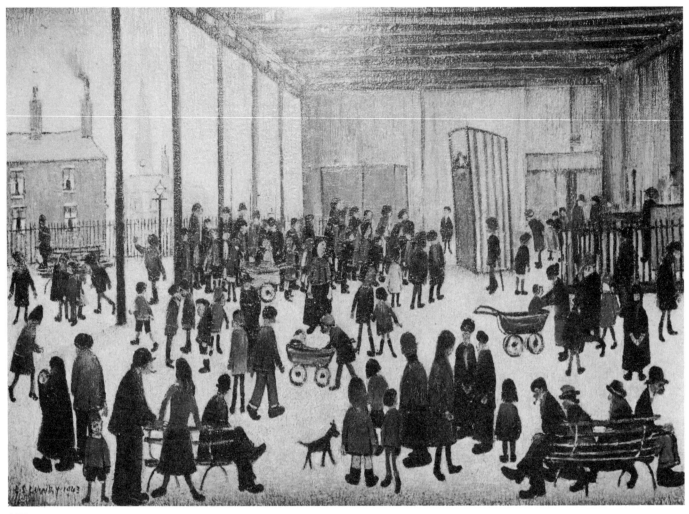

137

148
Market Day

1943
Pencil, $14\frac{3}{4} \times 11$
Private Collection

149
Mill Scene with Figures

1944
Oil, 17×21
Private Collection

150
The Prayer Meeting

1944
Oil, 20×28
Private Collection

151
The Board Meeting

1944
Oil, 20×30
Private Collection

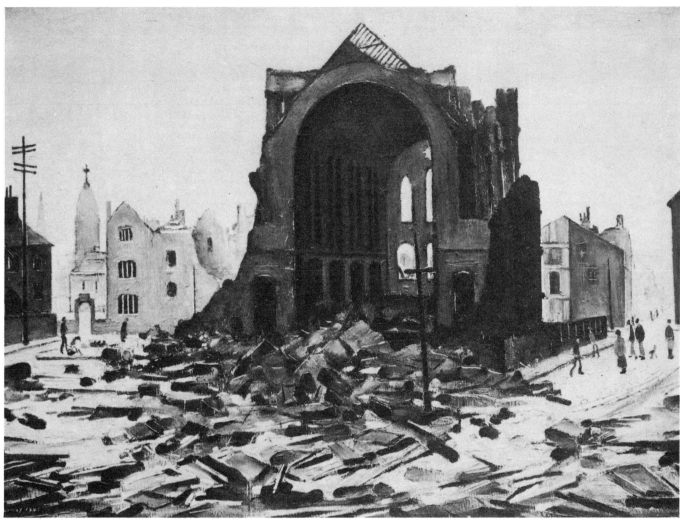

160

152
After the Match

1944
Oil, 14 × 24
Private Collection

153
Factory Gate

1944
Oil, 15½ × 19½
Private Collection

154
Lancashire Cotton Worker

1944
Oil, 20½ × 16
Lent by the City Art Gallery, Leeds

155 *Illustrated in colour on p. 24*
The Mansion, Pendlebury

1944
Oil, 17 × 21
Private Collection

156
Stockport Viaduct

1944
Oil, $23\frac{1}{2} \times 19\frac{1}{2}$
Private Collection

157
Seascape

1944
Pencil, 12×14
Lent by Dr. J. M. Maitland

158
Drawing for the Board Meeting

c. 1944
Pencil, 11×15
Private Collection

159 *Illustrated on front cover*
VE Day

1945
Oil, 31×40
Lent by the Museums and Art Galleries, Glasgow

160 *Illustrated*
St. Augustine's Church, Manchester

1945
Oil, $18\frac{1}{4} \times 24$
Lent by the City Art Galleries, Manchester

161
Industrial Landscape – The Canal

1945
Oil, 24×30
Lent by the City Art Gallery, Leeds

162
At the Mill Gate

1945
Oil, 16×18
Lent by Gordon Mellor, Esq.

163
Derelict Building

1945
Oil, $20\frac{3}{4} \times 17$
Lent by the Art Gallery and Museums, Aberdeen

164
St. Luke's Church, Old Street, E.C.

1945
Oil, 18×24
Lent by Gordon Mellor, Esq.

165
Sailing Boats and Figures

c. 1945
Oil, 10×14
Lent by E. Lionel Becker, Esq.

166 *Illustrated in colour on p. 26*
Good Friday, Daisy Nook

1946
Oil, 30×40
Private Collection

This is the major version of a number of pictures all depicting the area between Droylsden and Failsworth, where the annual Good Friday Fair takes place. Daisy Nook is also close to *Crime Lake* 1942 (135), another favourite holiday area in the vicinity of Manchester.

167
Worsley Coal Barge

1946
Oil, $10\frac{3}{4} \times 17$
Private Collection

168
Shield Hall Docks

1946
Pencil, $11\frac{1}{2} \times 14$
Private Collection

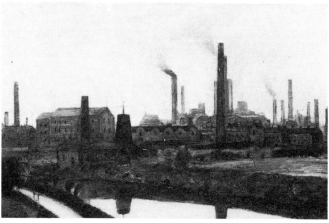

170

169
The Necropolis, Glasgow

1946
Pencil, 12 × 14
Lent by Dr. J. M. Maitland

170 *Illustrated*
The River Irwell at Salford

1947
Oil, 11 × 16¾
Lent by Monty Bloom, Esq.

171
Ironworks

1947
Oil, 24 × 20
Lent by Derbyshire County Council Museum Service

172
Tolbooth, Glasgow

1947
Oil, 21½ × 18
Lent by the Museums and Art Galleries, Wakefield

173
Ship entering Princess Dock, Glasgow

1947
Oil, 21½ × 18
Private Collection

174
Church, Wath Brow, Cleator Moor

1948
Pastel, 14¾ × 11
Lent by the Rev. Geoffrey S. Bennett

175
The Chip Shop, Cleator Moor

1948
Pastel, 11 × 14¾
Lent by the Rev. Geoffrey S. Bennett

176 *Illustrated*
The Cripples

1949
Oil, 30 × 40
Lent by the Museum and Art Gallery, Salford

This painting marks the beginning of the artist's more satirical, often highly cruel view of his fellows. *The Cripples* is another example of the artist's "composite" picture-making, gathering in the one deeply disturbing image a cross section of the afflicted.

Lowry's interest in cripples, tramps, drunks, derelicts and other strange and eccentric characters was to deepen from this point onwards. His social commentaries on the working-class ethos of the depression years is now extended into the dimension of pure satire with deformity and general oddity as its target.

See *In a Park* 1963 (285)
 Landscape with Figures 1957 (231)
 Man Drinking Water 1962 (275)

177
Agricultural Fair, Mottram-in-Longdendale

1949
Oil, 25½ × 30¾
Lent by Edward Goodstein, Esq.

178
The Fairground

1949
Oil, 20 × 24
Private Collection

179
Back view of Man in Wheelchair

c. 1949
Oil
Lent by The Hon. Robin Warrender

180
The Contraption

c. 1949
Pencil, 7½ × 4⅜
Lent by Mr and Mrs Andras Kalman

A drawing for a painting of the same title. The artist, who always had an eye for the eccentric and the extraordinary, recalled how he once saw this strange vehicle during his street wanderings: "There was a man travelling slowly along in an extraordinary upright box on wheels. I followed it. I couldn't help it. And the man had the face of a poet. Suddenly he stopped and turned on me! 'What the bloody hell are you following me about for?' he asked. And followed the remark with plenty more similar language, I felt a fool". Nevertheless the idea took firm root in the artist's imagination, and the contraption was to appear from time to time, quite out of context, in a number of street scenes.

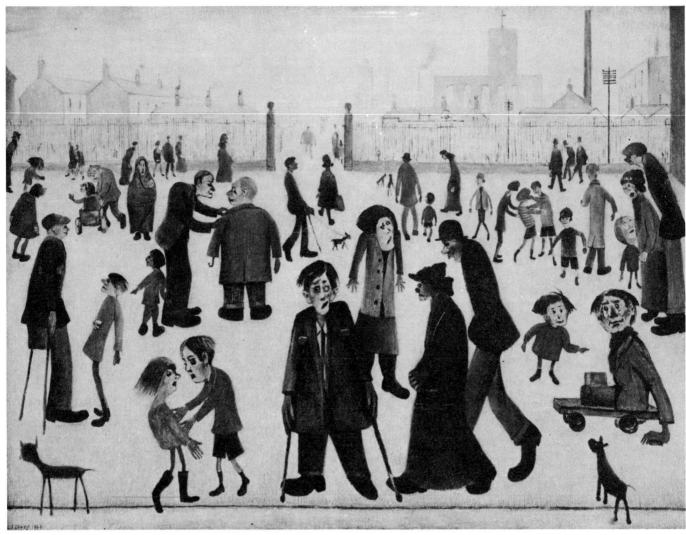

176

181
Odds and Ends: The Bennett Street Sunday School Magazine

1949-66
Lent by Manchester Central Library

The artist made a series of water-colour, pencil and pen
drawings for the *Odds and Ends* magazine between the years
1949 and 1960. Each copy of the magazine was handwritten
and pictorial contributions were pasted in. The Sunday School
was founded in 1801 and the building drawn by Lowry was
opened in 1818. When the School was closed in 1966, the

Odds and Ends magazines were bound into volumes and given
to the Archives Department of the Manchester Central Library.
The artist and his family were closely connected with the
Sunday School. His mother was an organist in the Adult Ladies
Room and he was a member of the Literary and Educational
Society.

(We are grateful to Mr R. A. Fletcher, a leading member of the
Bennett Street Sunday School, for drawing our attention to the
existence of this item)

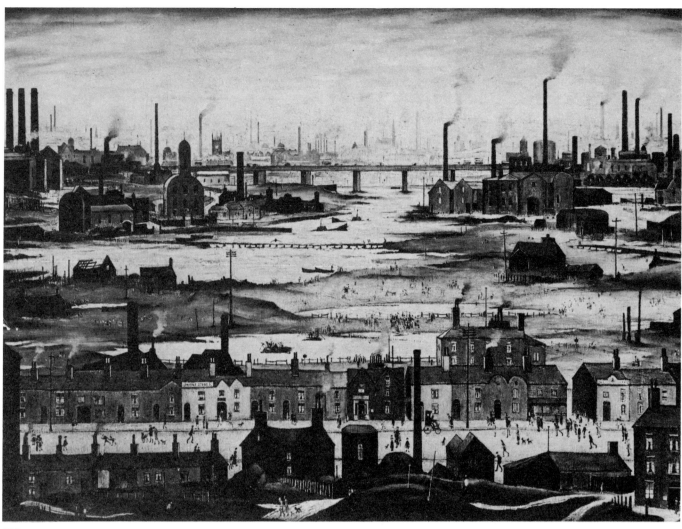

182

182 *Illustrated*
Industrial Landscape

1950
Oil, 44 × 60
Lent by Leicestershire Museums and Art Galleries

183 *Illustrated*
Father and Sons

1950
Oil, 30 × 40
Lent by M. D. H. Bloom, Esq. (On loan to Southampton Art Gallery)

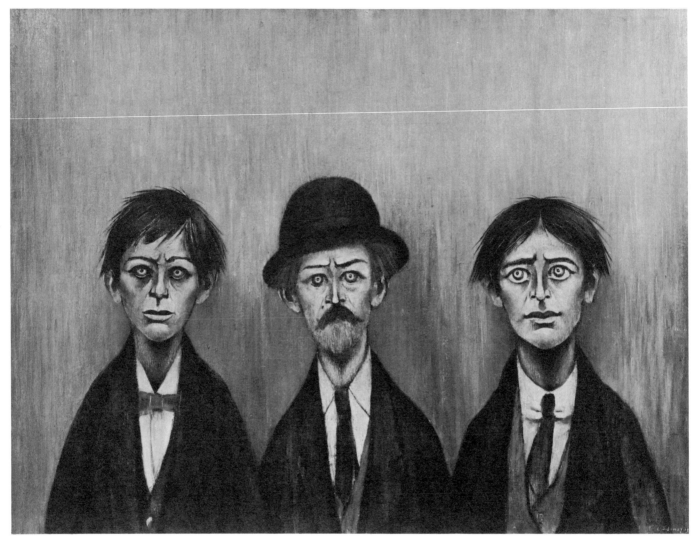

183

184
The Pond

1950
Oil, 45 × 60
Lent by the Tate Gallery

A massive "composite" industrial landscape, and one of the
artist's most perfect visions of the industrial scene purified
by the imagination and distilled into a design of marvellous
clarity. It contains every element of significance for an
understanding of the painter's mature vision. Gone is the
bronchial gloom of the early industrial paintings to be replaced
by a clean, crisp atmosphere. This is perhaps the Elysium
of the artist's dream; the pure poetry of the industrial landscape
– miraculous and shining. People and animals, buildings and
smoking stacks, the boats bobbing on the pond, and in the
background, and high up, the most haunting of all the artist's
grass-root images – the Stockport Viaduct – combine in a
glorious harmony.

Lowry once told the writer how the Stockport Viaduct
would suddenly materialise in a painting quite out of any literal
context. "It's with me all the time – somewhere" he said. "Just
waiting to appear. It haunts me."

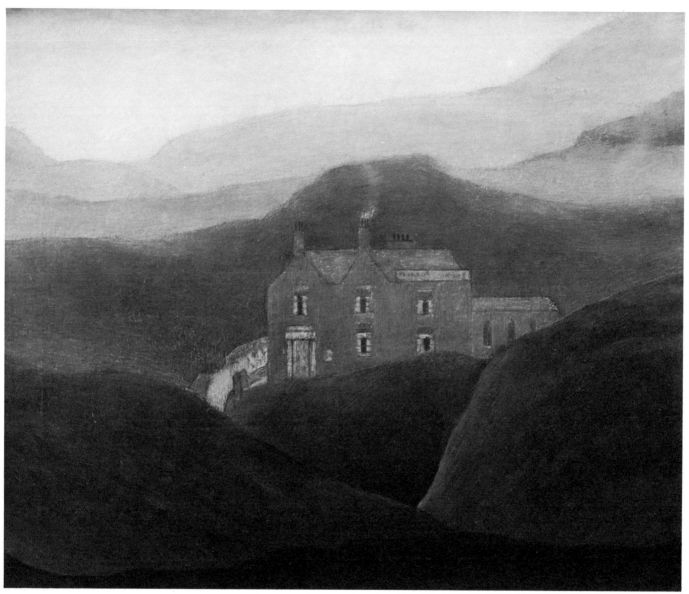

186

In a letter to the Tate Gallery, written in 1956, Lowry described his working method. "This is a composite picture . . . I hadn't the slightest idea what I was going to put in the canvas when I started . . . but it eventually came out as you see it. This is the way I like working best".

185
The Street Trader

1950
Oil, 19¾ × 23½
Private Collection

186 *Illustrated*
House on the Moor

1950
Oil, 20 × 24
Lent by the Museum and Art Gallery, Salford

187
Lake Landscape

1950
Oil, 28 × 36
Lent by the Whitworth Art Gallery, University of Manchester

188
Open Space

1950
Oil, 30 × 40
Lent by the Crane Kalman Gallery

189
St. Paul's Schools, Bennett Street

1950
Oil, 20 × 24
Lent by Fred Uhlman, Esq.

190
The Market Square, Cleator Moor

1950
Pastel, 9¼ × 14¼
Lent by the Rev. Geoffrey S. Bennett

191 *Illustrated*
Factory in Snow

1951
Oil, 14 × 10
Lent by Fred Uhlman, Esq.

192
The Gateway

1951
Oil, 13½ × 18
Lent by Peter Barkworth, Esq.

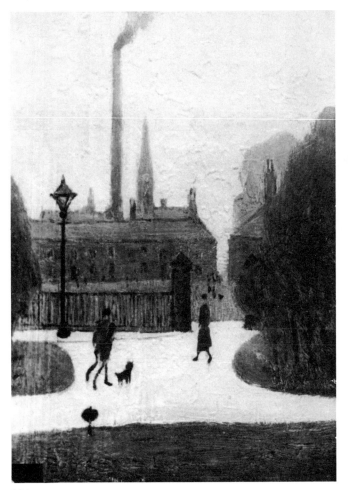

191

193 *Illustrated in colour on p. 27*
Open-air Meeting

1951
Pastel, 10½ × 14¾
Lent by the Rev. Geoffrey S. Bennett

194 *Illustrated*
Ancoats Hospital, Out-patients Hall

1952
Oil, 23¼ × 35½
Lent by the Whitworth Art Gallery, University of Manchester

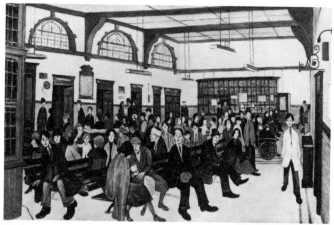

194

195 *Illustrated*
A Country Road

1952
Oil, 20 × 24
Lent by the Lefevre Gallery

196
The Boating Lake

1952
Oil, 29½ × 39½
Lent by Mr and Mrs Leslie Paisner

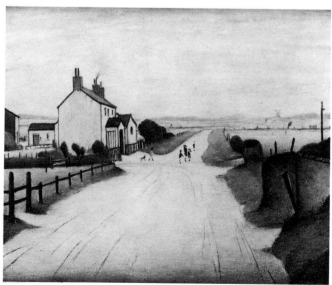

195

197
Industrial Landscape

1952
Oil, 45¼ × 60
Lent by Cartwright Hall, Bradford Art Galleries and Museums

198 *Illustrated*
Going to the Match

1953
Oil, 28 × 36
Private Collection

One of the many football subjects painted by the artist, who was always keenly interested in sport: football and cricket in particular. Many of these pictures have either direct or imaginary links with Burnden Park, Bolton, home of Bolton Wanderers Football Club, a ground only a few miles from Pendlebury and often visited by the artist as a young man. However, as with so many of his Industrial Landscapes, his football pictures are usually a "composite" of the actual and the imaginary, incorporating a variety of elements from the stock mythos of the artist's imagery. Factories, buildings and streets, woven into a "vision". As he said to the writer, "If I had shown things as they are – it would not have looked like a vision. So I had to make up symbols. With my figures also, of course".

The picture is therefore not a picture of a particular football match but a " vision" of all football matches.

199
The House on the Corner, Manchester

1953
Oil, 14 × 20
Lent by Henry Donn Galleries, Manchester

200
The Green Drive; Lytham in Winter

1953
Oil, 8½ × 15
Lent by Bruce Sharman, Esq.

201
Railway Platform

1953
Oil, 15½ × 30
Lent by the Lefevre Gallery

202 *Illustrated*
Industrial Panorama

1953
Oil, 23 × 31
Lent by the Castle Museum and Art Gallery, Nottingham

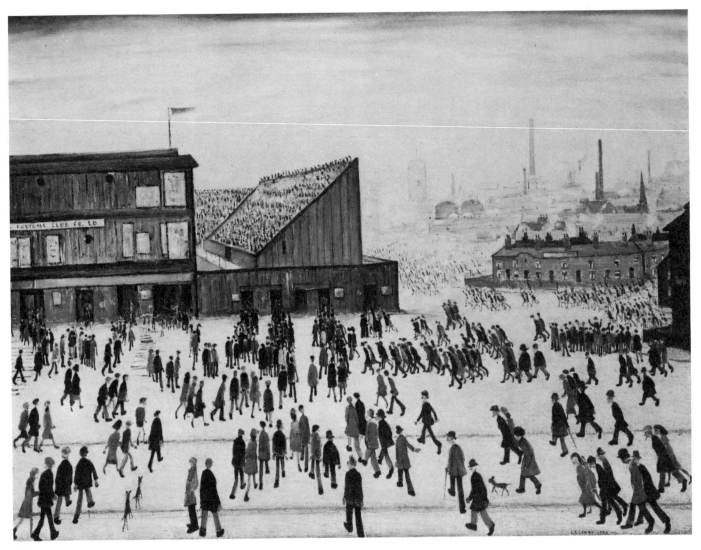

198

203
The Ferry, Knott End

c. 1953
Oil, 18 × 24
Private Collection

204
The Ferry Slip at Knott End on Sea

c. 1953
Pencil, 10 × 13½
Lent by Mrs Martha Lowry

205
Going to the Match

c. 1953
Pencil, 8 × 10
Private Collection

This is a rough sketch for the painting of the same title (198)

206 *Illustrated*
Business Gents

1954
Oil, 36 × 26
Lent by L. Trevor Donaldson, Esq.

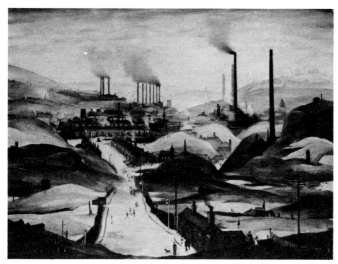

202

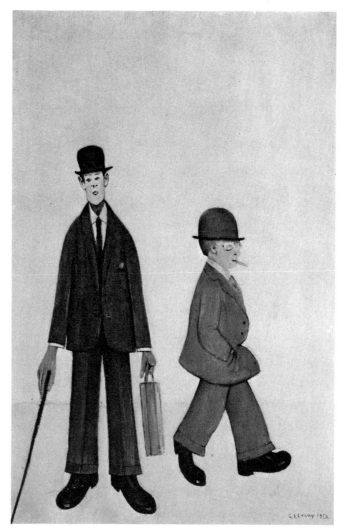

206

207
Near Whitehaven

1954
Oil, $20\frac{1}{4} \times 30$
Lent by Antony St. John Davies, Esq.

208
Landscape with Farm Buildings

1954
Oil, $15\frac{7}{8} \times 19\frac{3}{4}$
Lent by the Castle Museum, Norwich

209
Holcombe Races

1954
Oil, $8\frac{1}{2} \times 6$
Lent by Mrs E. M. Taylor (on loan to Bolton Museum and Art Gallery)

210
Canal and Factories

1955
Oil, 24×30
Lent by the Scottish National Gallery of Modern Art, Edinburgh

211
The Farm

1955
Oil, 20×24
Lent by the Lefevre Gallery

212 *Not in Exhibition*

213
Courting

1955
Crayon, $14\frac{1}{2} \times 10\frac{1}{2}$
Private Collection

An exquisitely cruel comment on the problem of communication.

214
At the Seaside

1955
Pen, $10\frac{1}{4} \times 14$
Lent by the Rev. Geoffrey S. Bennett

A scathing example of the artist's expressionist method. With a
minimum of means he distils the very essence of the scene.
As a social commentary in the best satirical vein it ranks
with Rowlandson.

215
Children, Houses and a Dog

1955
Pencil, $10\frac{1}{4} \times 14\frac{1}{4}$
Private Collection

216
Girl standing with Hands clasped

c. 1955
Pencil, $16\frac{1}{2} \times 11\frac{3}{4}$
Lent by permission of the Executors of the late L. S. Lowry

217
Sailing Ships

1956
Oil, $5\frac{1}{2} \times 8\frac{1}{2}$
Lent by Miss Helen Kapp

218
The Raft

1956
Oil, $20 \times 23\frac{1}{2}$
Lent by Mrs J. Aboulafia

219
The Junction

1956
Oil, 20×16
Lent by Mr and Mrs Andras Kalman

220
The Floating Bridge, Southampton

1956
Oil, 20×30
Lent by the Art Gallery, Southampton

221
On Location

1956
Oil, 24×36
Lent by Miss Wendy Toye

222
Mill Scene

1956
Pastel, 10×14
Private Collection

223
Sketch for Woman with a Beard

1956
Pencil, $8\frac{1}{2} \times 5\frac{1}{2}$
Lent by Monty Bloom, Esq.

A working note for the painting of the same title. See 230.

It is one of the artist's rare, real portraits. He recalled how, on
one occasion when journeying by train from Cardiff to
Paddington, a bearded woman got into his carriage at Newport.

"She had a very nice face, and quite a big beard. Well sir,
I just couldn't let such an opportunity pass, so I began almost
at once to make a little drawing of her on a piece of paper.
She was sitting right opposite me. After a while she asked,
rather nervously, what I was doing? I blushed like a Dublin
Bay prawn and showed her my sketch – the one from which I
later made my painting of her. At first she was greatly
troubled, but we talked, and by the time the train had reached
Paddington we were the best of friends. We even shook hands
on the platform. People say, 'Oh, but you couldn't have seen a
woman with a beard like that!' But I did, you know. They said
the same thing about my painting of the bearded lady I saw
pushing a pram in Winchester. But I saw her too! Although I'm
afraid she wasn't quite so nice. The moment I saw the good
lady I pulled a scrap of paper from my pocket and hurried
alongside her scribbling away. Well, my dear sir – her language
– Oh! it was quite appalling! Oh, terrible! I wouldn't dare
repeat what she called me!''*

Painters of Today, L. S. Lowry, ARA, London: Studio
Books, 1961; p. 10

224
Boats

1956
Pencil, $10 \times 13\frac{1}{2}$
Lent by the Museum and Art Gallery, Salford

225
Francis Terrace, Salford

1956
Pencil, $10 \times 13\frac{3}{8}$
Lent by the Museum and Art Gallery, Salford

226
Ann

1956
Pencil, $14\frac{1}{2} \times 9$
Private Collection

230

231

227
Clitheroe

1956
Pencil, *c.* 12 × 9½
Lent by Mrs Prudence Kunzel

228
Park, Aspatria

1956
Pencil, 13½ × 10
Lent by Miss Sheila Fell

229
Tanker at Anchor

c. 1956
Pencil, 10 × 13¾
Private Collection

230 *Illustrated*
Woman with a Beard

1957
Oil, 24 × 20
Lent by M. D. H. Bloom, Esq.

See *Sketch for Woman with a Beard* (223)

231 *Illustrated*
Landscape with Figures

1957
Oil, 15 × 11
Lent by Mrs E. M. Taylor (On loan to Bolton Museum and Art Gallery)

See *The Cripples* (176)

232
Piccadilly, Manchester

1957
Oil, 18 × 24
Lent by Howard Thomas, Esq.

233
Old Road, Failsworth

1957
Oil, 15 × 20
Lent by L. Jacobson, Esq.

234
"Up North" (School and Street with Factory Background)

1957
Oil, 12 × 16
Lent by Howard Thomas, Esq.

235
Francis Street, Salford

1957
Oil, 16⅛ × 20
Lent by the Museum and Art Gallery, Newport

236
Mersham-le-Hatch (South Side)

1957
Oil, 20 × 24
Private Collection

237
Mersham-le-Hatch (North Side)

1957
Oil, 22½ × 32½
Private Collection

238
The Auction

1957
Oil, 25 × 30
Lent by Harry Finegold, Esq.

239

239 *Illustrated*
Beach Scene

1957
Pencil, 6½ × 8¼
Lent by the Rev. Geoffrey S. Bennett

In his later work the artist used an increasingly loose style; either to capture the essence of a subject, or to intensify his mounting sense of satire and hostility. (See *At the Seaside* 1955 (214).) In a drawing such as this he has distilled the essentials of the scene with a minimum of means. A few stabs and strokes of the pencil and a bit of subtle smudging are all that is required to create space, distance, bobbing boats, much human activity and atmosphere.

240
The Auction

1957
Pencil, 10½ × 14¼
Lent by the Rev. Geoffrey S. Bennett

241
Beach Scene

1958
Oil, 6¾ × 8¼
Lent by the Rev. Geoffrey S. Bennett

See Valette's *Manchester Cathedral* 1910 (43)

242
Street Scene

1958
Oil, $15\frac{1}{2} \times 19\frac{1}{2}$
Lent by Mrs Sylvia Shine

243
Northern Race Meeting

1958
Oil, $29\frac{1}{2} \times 39\frac{1}{2}$
Lent by Mrs Sylvia Shine

244
Market Square

1958
Oil, $17\frac{1}{2} \times 25$
Lent by Mrs Sylvia Shine

245
The Old Town Hall, Middlesbrough

1958
Oil, 17×12
Private Collection

246
The Cart

1959
Oil, 20×16
Private Collection

247
The Stone Circle, Cornwall

1959
Oil, 20×24
Lent by Bruce Sharman, Esq.

248
On the Sands, Berwick

1959
Oil, $19\frac{1}{2} \times 23\frac{1}{2}$
Lent by Mrs Sylvia Shine

249
Woman with a Shopping Bag

1959
Oil, $15\frac{3}{4} \times 4\frac{3}{4}$
Lent by Miss Helen Kapp

250
Yachts

1959
Water-colour, $10\frac{1}{2} \times 14\frac{3}{4}$
Lent by the Museum and Art Gallery, Salford

Water-colour is the one medium which the artist used only occasionally. It is likely that its obvious limitation – speed of drying – made it a less suitable vehicle for his thoughtful temperament than pastel, or of course oils, both of which can be developed at leisure.

However, when he wished he could use water-colour with great ability, and when he did his style was always delightfully fluent and spontaneous.

251 *Illustrated*
Man searching a Dustbin

1960
Oil, $9\frac{1}{4} \times 7\frac{1}{2}$
Lent by Mrs Phyllis Bloom

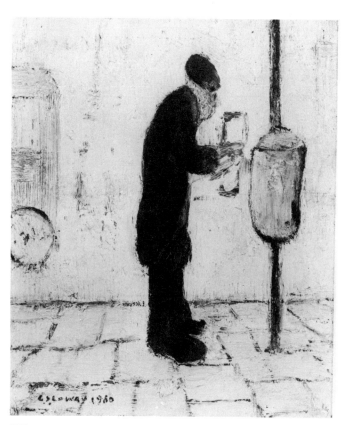

251

252
Ebbw Vale

1960
Oil and gouache, 45 × 60
Lent by Coventry Libraries, Arts and Museums Department

In the 1960's, the artist made a number of brief annual visits
to South Wales. He went with a friend to visit a fortune-teller
in the Rhondda Valley. But inevitably the grandeur of the
industrial areas made a great impression on him and he
produced variations on the theme of the northern urban
industrial landscape which by contrast often exhibit a curious
rural flavour.

253
Mostyn Bottom

1960
Oil, 5¼ × 7½
Lent by Mr and Mrs Andras Kalman

254
Accident on the Bridge

1960
Oil, 10⅛ × 12⅛
Lent by Mr and Mrs Andras Kalman

255
Piccadilly Circus, London

1960
Oil, 30 × 40
Private Collection

256
Portrait of a Boy

1960
Oil, 19½ × 15½
Private Collection

257
Mill Scene

1960
Oil, 12 × 16
Lent by The Pall Mall Property Co. Ltd., Manchester

258
The Assignation

1960
Oil, 15¾ × 4
Lent by Mrs Phyllis Bloom

259
Figures in a Street

1960
Oil, 8½ × 8
Private Collection

260
Ship Approaching Harbour

1960
Oil, 23 × 29
Private Collection

261
Ferry Boats

1960
Oil, 12 × 15¾
*Lent by Dr. R. Hemphill (On loan to Bristol City Museum and
Art Gallery)*

262
A Late Caller

c. 1960
Oil, 20 × 16
Lent by Robert Arkle, Esq.

The artist described the subject (of which there are other
versions) as a picture of "someone" who rang his door-bell late
one Christmas Eve, but who departed just before he opened
the door. So he never knew who it was. The close relationship
which this mysterious presence bears to the figure in *A Visit to
Burton-on-Trent* (281) suggests a *Doppelgänger* situation. This
would not be inconsistent with the loneliness of the artist's life.

See *The Christmas Eve Caller c.* 1960 (265)

263
Drunken Man

1960
Pencil, 14½ × 9½
Private Collection

A delightful note on human frailty. The artist saw this
character propped against a wall in Burton-on-Trent, "drunk
and unable to find his way home".

264
Outgang Road, Aspatria

1960
Pencil, 13 × 9½
Lent by Miss Sheila Fell

265
The Christmas Eve Caller

c. 1960
Pencil, $13\frac{1}{2} \times 9\frac{1}{2}$
Private Collection

 See *A Late Caller c.* 1960 (262)

266
Two Gentlemen

c. 1960
Pencil and charcoal, $9\frac{1}{2} \times 13$
Lent by Miss Sheila Fell

267 *Illustrated in colour on p. 28*
The Mill – Early Morning

1961
Oil, 18×16
Lent by the National Westminster Bank Ltd.

268
Family Group

1961
Oil, $12\frac{1}{2} \times 5$
Lent by Mrs Phyllis Bloom

A ferociously expressionist painting which relies upon its brutal distortions to endorse the hapless idiocy of the mother, father and son. No Expressionist – not Kokoschka, not Soutine, not even Grosz – could have established a more destructive or malicious image.

 The clumsy rendering of the hands recalls the student years (See *Model with Head-dress* 1918 (25)) only here the distortion is intentional.

269
Market Stalls

1961
Oil, 30×39
Lent by Marks and Spencer Ltd.

270
The River Wear at Sunderland

1961
Oil, $20\frac{1}{2} \times 24$
Lent by Sunderland Museum (Tyne and Wear County Museums Service)

271
Wreck at South Shields

1961
Pencil, $10 \times 13\frac{3}{4}$
Lent by permission of the Executors of the late L. S. Lowry

272
Gentlemen walking

1961
Pencil, $13\frac{3}{4} \times 10$
Lent by Monty Bloom, Esq.

273 *Illustrated*
Man Playing a Harp

1962
Oil, $31\frac{1}{2} \times 22\frac{1}{2}$
Private Collection

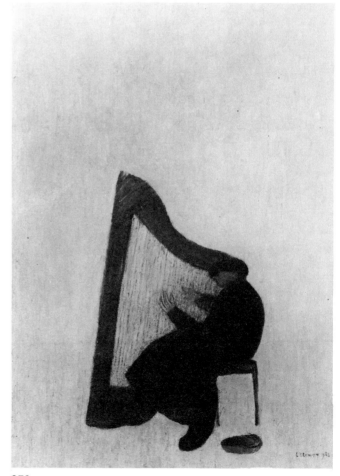

273

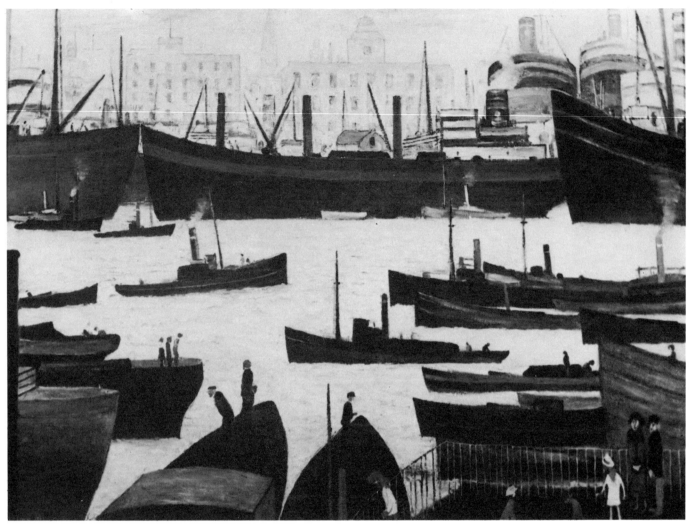

274

274 *Illustrated*
South Shields

1962
Oil, 30 × 40
Lent by the Crane Kalman Gallery

During the latter part of his life the artist often spent long
periods away from Mottram. He spent weeks at a time living
at the Seaburn Hotel in Sunderland. From here he could make
easy taxi journeys to the docks at South Shields where he
made many drawings and paintings of the bustling port
on the mouth of the Tyne.

275 *Illustrated*
Man drinking Water

1962
Oil, 14¾ × 12½
Lent by M. D. H. Bloom, Esq.

See *The Cripples* 1949 (176)

276
Station Approach

1962
Oil, 16½ × 20
Lent by the Royal Academy of Arts

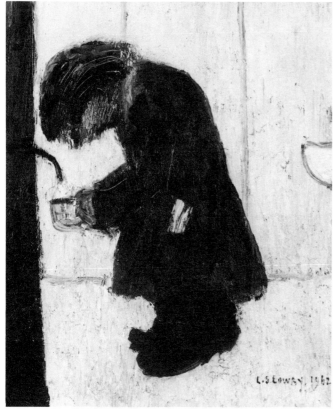

275

280
The Carriage

c. 1962
Oil, $19\frac{1}{2} \times 29\frac{1}{2}$
Lent by H.M. The Queen

281
A Visit to Burton-on-Trent

1962
Pencil, $15\frac{1}{2} \times 10\frac{3}{4}$
Lent by John Maxwell, Esq.

This curious drawing was made after a visit to Burton-on-Trent.
The artist told the writer that on this occasion he found himself
in an unexpected passage-way leading "nowhere". Soon after
the visit he made this drawing which is a portrait of the artist
looking, as he said "Nowhere!" It is strongly reminiscent of the
painting *A Late Caller c*. 1960 (262).

282
Study for Man drinking Water

1962
Pencil, $13\frac{3}{4} \times 10\frac{1}{4}$
Lent by Monty Bloom, Esq.

283
Seamen's Hostel

1962
Pencil, $14 \times 9\frac{1}{2}$
Lent by Miss Sheila Fell

277
Crowded Platform at Paddington Station

1962
Oil, 20×24
Private Collection

278
Figures with Church and Bollards

1962
Oil, $11\frac{1}{2} \times 10\frac{1}{2}$
Private Collection

279
The Waterloo Dock

c. 1962
Oil, 23×32
Private Collection

284 *Illustrated*
Sea Trials at South Shields

1963
Oil, 20×30
Private Collection

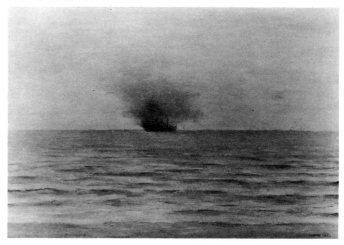

284

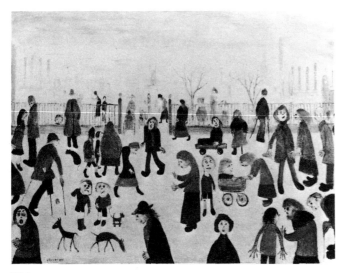

285

288

285 *Illustrated*
In a Park

1963
Oil, 30⅛ × 40⅛
Lent by the Whitworth Art Gallery, University of Manchester

See *The Cripples* 1949 (176)

286
Figures in a Town

1963
Oil, 15½ × 11½
Private Collection

287
Two Women crossing a Road

1963
Oil, 12 × 16
Lent by the Rev. Canon Gwilym Morgan

288 *Illustrated*
Bird looking at Something

1964
Oil, 6¼ × 6⅛
Lent by Monty Bloom, Esq.

Lowry was always very taken with the idea of people, animals
or birds looking at something no one else could see. On one
occasion watching a cat frozen in an ecstasy of looking, he
turned to the writer and said "If we could only see one half of
whatever it is that cat can see, we'd know a lot more than we
do, Sir!".

Always witty, these subjects evoke a sense of intense
curiosity.

The titles are always carefully constructed and relate to the
image in the most telling manner.

289
A Man Waiting

1964
Oil, 18 × 14
Lent by Keith Ewart, Esq.

290
Back View of a Girl

1964
Oil, 23½ × 19½
Private Collection

Always aware that the back of a figure can convey as much
interest as its front – often more – in this picture and its partner
Front View of a Girl 1964 (291) the artist has developed an idea
which first emerged in 1960. In this year he painted a picture
which combines the front and the back view of a young woman
simultaneously moving towards, and away from the spectator
in an area of total whiteness. When I asked the artist for its

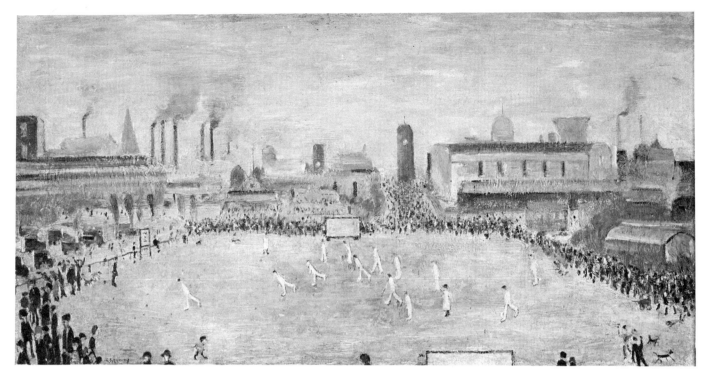

294

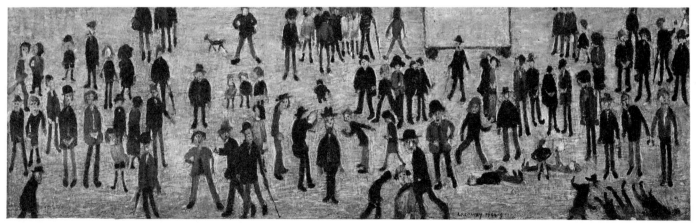

295

title he pondered for a moment and then replied with a mischievous smile: "Let's call it the same woman coming back!"

The idea, as here, is characteristically humorous and eccentric.

291
Front View of a Girl

1964
Oil, $23\frac{1}{2} \times 19\frac{1}{2}$
Private Collection

292
Man in a Doorway

1964
Oil, $17\frac{3}{4} \times 14$
Lent by Keith Ewart, Esq.

293
Church Street, Clitheroe

1964
Oil, *c.* 18×14
Lent by Mrs Prudence Kunzel

294 *Illustrated*
Lancashire League Cricket Match

1964-69
Oil, 30×15
Private Collection

The artist was always keenly interested in sport. He drew and
painted many football scenes. But there is also one intriguing
cricket picture. This was originally painted on one canvas, but
now exists in two parts (See *Crowd Around a Cricket Sight Board*
(295)). The story of this picture was told to the writer by
Alick Leggat, a long-standing friend of the artist and for many
years Honorary Treasurer of the Lancashire County Cricket
Club. The picture, now in two pieces (see also 295), was produced
over a lengthy period between 1964 and 1969, Mr Leggat
having supplied the artist with details of the field positions.
Lowry, however, was not satisfied with the result and promptly
cut the picture in two. The lower and smaller section was
partially repainted, and if, as I have done, one puts the two
parts together again, making one picture, it is possible to see
quite clearly why the artist was not satisfied. Almost none of
the figures in the lower section are actually looking at the
players. They are turned towards the spectator and it appears
that, when the artist got involved in this area, he became
engrossed in problems of construction that had little, if any,
relationship to the game being played in the upper part. On the
reverse of this portion of the painting is a pasted statement by
the artist which reads: "This picture of a *Crowd around a Cricket
Sight Board* is the lower portion of a larger canvas measuring
originally 30×25. Owing to the difficulty of reconciling the
two portions, I decided to make two separate pictures. This is a
smaller portion mounted on board and mahogany and I
consider it one of my most successful crowd scenes. L. S. Lowry,
29 April 1970."

295
Crowd Around a Cricket Sight Board

1964-69
Oil, 30×15
Private Collection

See 294

296
Tanker

c. 1964
Oil, $6\frac{1}{2} \times 16$
Lent by permission of the late L. S. Lowry

297 *Illustrated*
Lady in a Straw Hat without a Dog

1964
Pencil, 14×10
Lent by Mrs Barbara Sage

See *Head of a Man with Red Eyes* 1938 (122)

298 *Illustrated in colour on p. 29*
Bargoed

1965
Oil, 48×60
*Lent by M. D. H. Bloom, Esq. (On loan to Southampton Art
Gallery)*

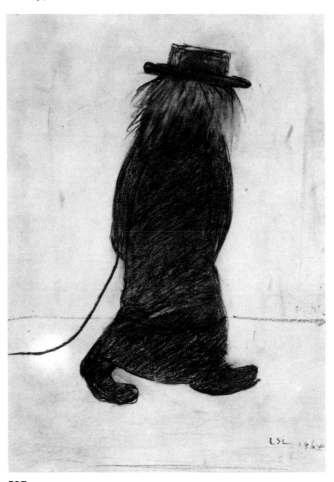

297

299
Back of a Man

1965
Oil, $7\frac{1}{2} \times 5\frac{1}{4}$
Lent by A. R. Oldham, Esq.

300
Open Space

1965
Oil, $21\frac{1}{2} \times 33\frac{1}{2}$
Private Collection

301
Industrial Scene

1965
Oil, 22×34
Lent by the Whitworth Art Gallery, University of Manchester

302
People Walking Towards the Sea

1965
Oil, 20×30
Private Collection

303
Mill Scene

1965
Oil, $19\frac{1}{4} \times 23\frac{1}{2}$
Lent by the Museum and Art Gallery, Salford

304 *Illustrated*
Five Ships

c. 1965
Oil, $15\frac{3}{4} \times 22\frac{1}{4}$
Lent by permission of the late L. S. Lowry

305
Two Boys Playing

1965
Pencil, $5\frac{1}{4} \times 6\frac{1}{2}$
Private Collection

306 *Illustrated in colour on p. 30*
Grey Sea

1966
Oil, $29\frac{1}{2} \times 39$
Lent by J. P. Jacobs, Esq.

In later years empty seascapes such as this exert an increasing fascination for the artist. Earlier, as in the Lytham scenes, or the beach pictures, the water is pleasantly set with yachts and boats. But there seems no doubt that in the last years of his life, the sea ceased to represent holidays, or summer-time, and came to symbolise a dimension of experience yet to reveal its mysteries. Indeed, the artist's imagery, always subtle, often contains profound double-meanings. Things are usually more than they might seem at first sight. Represented, as here, in a deeply serene and contemplative manner, the ocean stretches away out of life itself to the infinite horizon of the unknown.

307 *Illustrated*
Boy with a Stomach-ache

1966
Oil, 16×12
Lent by the Rev. Geoffrey S. Bennett

308
Town Centre

1966
Oil, 24×20
Lent by the Lefevre Gallery

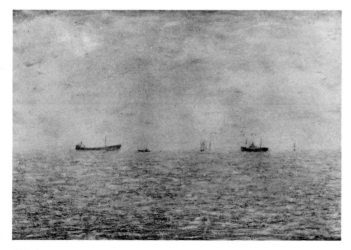

304

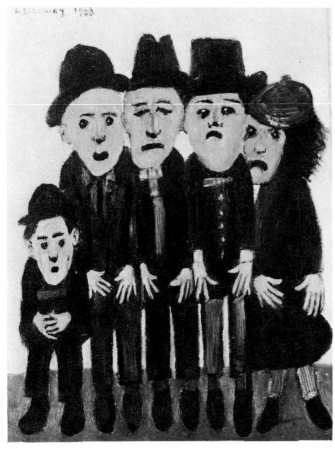

307

309
Mother and Child

1967
Oil, $6\frac{3}{4} \times 3\frac{3}{4}$
Lent by the Rev. Geoffrey S. Bennett

Lowry was a master of wide range, both in his choice of subject and in the variability of his technical methods. He could exercise a tight control over his media or, as here, paint with a glittering freshness of style that served to emphasise his wit and sense of humour.

His later paintings are often rendered with great freeness, the colours flowing easily and loosely from the brush.

310
Going to Work

1967
Oil, 12×10
Lent by Mrs Ellen Solomon

See *Mill Scene* 1971 (324)

311
Mother and Sons

1967
Oil, 20×16
Lent by Monty Bloom, Esq.

312
Cart with Children

1967
Oil, $13\frac{1}{2} \times 9\frac{1}{2}$
Private Collection

313
Ten People on a Promenade

c. 1967
Oil, $13\frac{1}{2} \times 9\frac{1}{2}$
Lent by Austin McCracken, Esq.

314
Man looking out to Sea

1968
Oil, 14×10
Private Collection

315
Family Discussion

1968
Pencil, $13\frac{1}{2} \times 9\frac{1}{2}$
Lent by Mr and Mrs M. Geller

316
Going to the Match

1968
Pencil, $16\frac{1}{2} \times 11\frac{1}{2}$
Private Collection

See *Head of a Man with Red Eyes* 1938 (122)

317
Man Fallen down a Hole

c. 1968
Pencil, $16\frac{1}{8} \times 11\frac{3}{4}$
Lent by permission of the Executors of the late L. S. Lowry

See *Head of a Man with Red Eyes* 1938 (122)

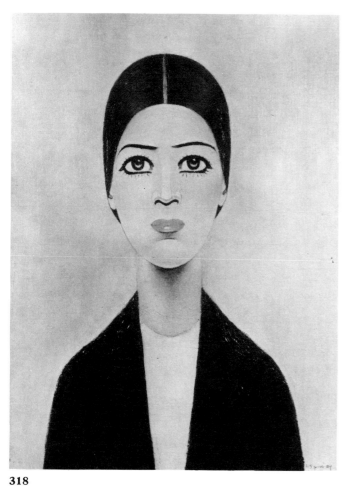

318

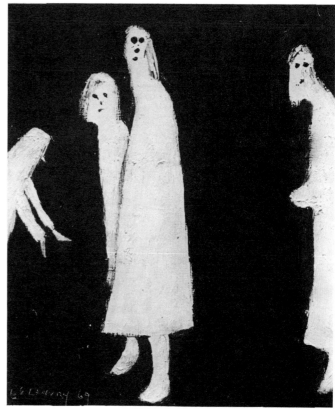

319

318 *Illustrated*
Portrait of Ann

1959
Oil, 22½ × 18½
Lent by permission of the late L. S. Lowry

During the 50's and 60's the artist made a number of paintings
and drawings of "Ann" (see *Ann* 1956 (226)). They are all
"composite", archetypal portraits; partly his god-daughter
Ann Hilder and partly evocations of his mother, and the
daughter of a farmer in Swinton Moss near Lytham St. Annes
whom Lowry had met and grown close to on childhood holidays.
She was also named Ann, and died when still a young girl
in 1913.

"Ann" was therefore one of the Lowry "dream women" and
played a role in his personal mythology similar to that occupied
by the women of Rossetti, an artist for whose sultry, goitred
"stunners" Lowry possessed a consuming passion. His private
collection contained a number of Rossetti portraits.

319 *Illustrated*
The Haunt

1969
Oil, 7 × 6
Private Collection

320
Ship and Headland

1970
Oil, 6½ × 12½
Private Collection

321
Waiting for the Tide, South Shields

1970
Oil, 4½ × 6½
Private Collection

322
Grotesque Figures

1970
Pencil, $16\frac{1}{4} \times 11\frac{1}{2}$
Private Collection

In the last few years of his life the artist produced a number of drawings packed with grotesque images. They are intensely subjective and represent, I believe, a range of phantoms disgorged from the artist's personal mythology of hopes and fears, loves and hates, successes and failures. The symbols are personal. Love lost; infirmity gained. The clamouring hostility of the world (and the artist's hostility *towards* the world) and, in the bottom centre of the drawing a creature which it seems can only epitomise the devilish frustration of the libido denied. His private life was in every respect acutely abstemious.
It is a drawing of immense psycho-analytical portent.

323 *Illustrated in colour on p. 32*
The Notice Board

1971
Oil, $15\frac{3}{4} \times 19\frac{3}{4}$
Lent by The Manchester Club

324
Mill Scene

1971
Pencil, $10\frac{1}{2} \times 8\frac{1}{2}$
Private Collection

This late industrial scene, or 'dreamscape' as the artist sometimes described such evocations, is a compact, clean crystallization of all the elements that are most typical of his vision. As he grew older the dream became less spreading and diffuse. It grew simpler and more concentrated. The interest is focused in one, stately building. It is perhaps synonymous with home.

325
Men in a Boat

1971
Pencil, $9\frac{1}{2} \times 14\frac{1}{2}$
Private Collection

326
Industrial Scene with Monument

1972
Oil, $10\frac{1}{2} \times 9\frac{1}{2}$
Private Collection

A late "composite" picture, but one of particular interest. As he aged the artist's work became increasingly more subjective and autobiographical (*Grotesque Figures* 1970 (322)). When I asked him for the story of this painting he answered: "Well, Sir, I suppose you can say the Monument is me! That's all I am now, you know. A monument to myself! What a way to end up!" His sense of humour was often delicately self-mocking.

The subject of monuments and landmarks had often been dealt with before. Sometimes, perched on top of the hills, they indicate the personal loneliness and isolation of the artist. But in earlier years they are watching, observing images. Now, in this picture painted when the artist was eighty-five, the world hurries by; the artist has seen it all. The monument is blind.

327
Gentlemen with Little Girl

1975
Pencil, $7 \times 4\frac{3}{4}$
Lent by Ceri Levy, Esq.

This mysterious little drawing is one of many similar notations made by the artist in the last year of his life. Is it an evocation of lost youth? A social comment? A Freudian slip? Why should a man's soul be subject to solution? Let the viewer conjecture at will.

More to the point is the charming story of how the drawing passed to the present owner, a fifth-former at Framlingham College, Suffolk. Taken by his father – the writer – to visit the artist at Mottram in August 1975, the young man produced his autograph-book and asked the artist if he would be kind enough to sign it. Reflecting deeply and sullenly for a moment Lowry remarked gravely "Oh! no! – I don't do that sort of thing anymore – I'm too old!" And then, with a broad smile and a mischievous chuckle he popped his hand into a pile of papers and pulled out this little sketch. "But you can have this if you like" he said: "I did it last night! – would you like me to sign it!".

328
Yachts at Lytham

1975
Pencil, $4\frac{3}{4} \times 7$
Lent by Ceri Levy, Esq.

Seventy-three years separate this little drawing from the one which opens the exhibition (1). The subject is the same. Only time has passed. Or has it? It is time regained in the classic Proustian sense. The Yachts at Lytham are where it all began...

Additional Items

The following works, all lent by kind permission of the Executors of the late L. S. Lowry, were too late to be included in the main body of the catalogue and are listed below.

329
The Artist's Mother
1906
Watercolour and pencil, $13\frac{1}{2} \times 9\frac{1}{2}$

330
Anatomy Sketchbook
1919
Pen and pencil, 10×8 (56 pages)

331
Salford Street Scene
1926
Pencil, $10\frac{1}{2} \times 14\frac{3}{4}$

332
Study for The Tennis Girl (cat. no. 73)
1926
Pencil, $12\frac{1}{4} \times 10\frac{1}{4}$

333
Two Sketches from The Floating Bridge, Southampton
(cat. no. 220)
1956
Pencil, $4\frac{1}{2} \times 7$ (each)

334
Sketch for Man Playing a Harp (cat. no. 273)
1963
Ball-point, $4\frac{1}{2} \times 7$

Select bibliography

Collis, Maurice. The Discovery of L. S. Lowry. Alex Reid & Lefevre Limited, London 1951.

Levy, Mervyn. L. S. Lowry. "Painters of Today" series. Studio Books, London 1961. Drawings of L. S. Lowry. Cory, Adams & Mackay, London 1963, and Jupiter Books London 1973. "Lowry and the Lonely Ones", The Studio, March 1963.

Mullins, Edwin. Introduction to L. S. Lowry: Catalogue of the Retrospective Exhibition. Tate Gallery and the Provinces, 1966-7. Organised by the Arts Council.

Levy, Mervyn. The Paintings of L. S. Lowry. Jupiter Books 1975.

Levy, Mervyn. L. S. Lowry 1887-1976. *New Statesman.* 27th February 1976.